# FASHION
## IN THE MIDDLE AGES

# MARGARET SCOTT

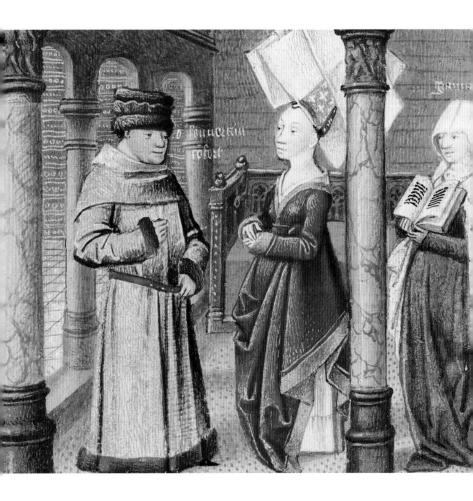

# FASHION
## IN THE MIDDLE AGES

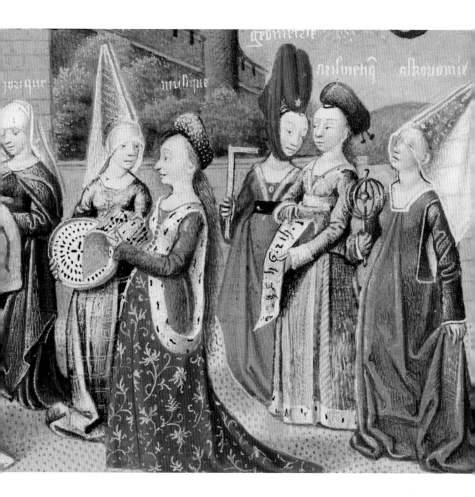

THE J. PAUL GETTY MUSEUM    LOS ANGELES

The hardcover edition of this publication was issued on the occasion of the exhibition *Fashion in the Middle Ages*, on view at the J. Paul Getty Museum at the Getty Center, Los Angeles, from May 31 to August 14, 2011.

**Published by the J. Paul Getty Museum, Los Angeles**
Getty Publications
1200 Getty Center Drive, Suite 500
Los Angeles, CA 90049–1682
getty.edu/publications

Elizabeth Morrison, *Consulting Editor*
Beatrice Hohenegger, *Editor*
Mollie Holtman, *Manuscript Editor*
Kurt Hauser, *Designer*
Amita Molloy, *Production Coordinator*

Photography and digital imaging services supplied by Stanley Smith, Rebecca Vera-Martinez, Michael Smith, and Johana Herrera of Getty Imaging Services

Distributed in the United States and Canada by the University of Chicago Press

Distributed outside the United States and Canada by Yale University Press, London

Printed and bound in China

**Illustration credits**
Every effort has been made to contact the owners and photographers of objects reproduced here whose names do not appear in the captions or in the illustration credits. Anyone having further information concerning copyright holders is asked to contact Getty Publications so this information can be included in future printings.

figs. 1, 8, 42 Photography © Art Institute of Chicago
figs. 14, 15, 45, 72 © Patrimonio Nacional (Spain)
figs. 51, 78, 81 © The British Library Board
fig. 79 Image courtesy Kunsthistorisches Museum, Vienna

All the remaining illustrations are from the collection of the J. Paul Getty Museum, indicated in the captions by the initials JPGM.

Front cover: *Louis XII of France Accompanied by Saints Michael, Charlemagne, Louis, and Denis* (detail, fig. 41)

Back cover: *Lydia Ordering the Death of Her Sons* (detail, fig. 5)

Frontispiece: *Philosophy Presenting the Seven Liberal Arts to Boethius* (detail, fig. 83)

**Author's Acknowledgments**
My gratitude to the Getty, in the guises of Thomas Kren, Ray Singer, and Brandi Franzman; I am especially grateful to Beth Morrison for all her care and patience in transforming my efforts from typescript to finished book, via the miracle of email. And, as ever, thank you to Jeff Avery.

**Library of Congress Cataloging-in-Publication Data**
Scott, Margaret, 1951–
 Fashion in the Middle Ages / Margaret Scott.
  p. cm.
 "This publication is issued in conjunction with the exhibition Fashion in the Middle Ages, on view at the J. Paul Getty Museum from May 31 to August 14, 2011."
 ISBN 978-1-60606-061-2 (hardcover)
 1. Clothing and dress in art—Exhibitions. 2. Fashion in art—Exhibitions. 3. Illumination of books and manuscripts, Medieval—Exhibitions. I. J. Paul Getty Museum. II. Title.
 ND3344.S36 2011
 391.009'02—dc22                    2010040059

ISBN 978-1-60606-585-3 (paperback)

**Sources for Quotations**
p. 9: François Deserps, *A Collection of the Various Styles of Clothing which are presently worn in countries of Europe, Asia, Africa, and the savage islands, all realistically depicted.* Sara Shannon, ed. (University of Minnesota Press: Minneapolis, 2001): 27, 31 (author's translation).

p. 13: Alexander Neckam, *De naturis rerum libri duo*. Thomas Wright, ed. (Rolls Series, 34: London, 1863): 352 (author's translation).

p. 47 (fig. 28): Bible (New American Standard Reference Version), Psalm 27: 4, 7–8.

p. 47 (fig. 29): Bible (New American Standard Reference Version), Psalm 53: 1.

p. 54: Guillaume de Lorris and Jean de Meun, *Le Roman de la rose*. Daniel Poirion, ed. (Garnier-Flammarion: Paris, 1974), ll. 20937–49 (author's translation).

p. 57: *Oeuvres de Georges Chastellain*. Kervyn de Lettenhove, ed. (Académie Royale de Belgique: Brussels, 1863): I, 178–9.

p. 93: Emilio Faccioli, ed., *Mantova: Le Lettere*, I (Istituto Carlo d'Arco per la storia di Mantova: Mantua, 1959): 59–60 (author's translation).

p. 95: Bible (New American Standard Reference Version), Psalm 27: 12.

# Contents

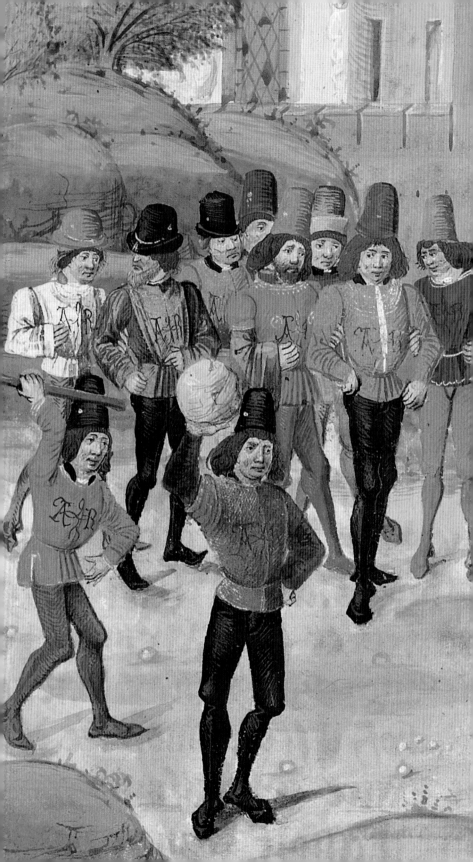

# Foreword

Some aspects of medieval fashion appear unfathomable to us today, such as women's dresses with sleeves so long that they hang well below the fingers, men's chokingly tight hoods, and shoes with pointy tips extending out six inches or more. Yet, what would those living in the Middle Ages have made of today's miniskirts, spike heels, or low-rider men's jeans? No doubt they would have found these fads just as incomprehensible. Through a careful consideration of manuscript images, this volume explores fashion developments in different periods and regions in the European Middle Ages. The author delves into the wider issue of medieval clothing and dress, from the dissimilar fabrics worn by peasants and royalty to the specialized costumes of monks and academics, taking into account, however, that manuscript images are not always to be considered exact reflections of period. Medieval artists often idealized, exaggerated, or modified the dress of their figures based on accepted artistic conventions or their own desire to convey aspects of a time or place beyond their knowledge.

I am grateful to Dr. Margaret Scott, former head of the History of Dress at the Courtauld Institute of Art, London (2001–2004), for her creative exploration of Getty manuscripts as well as for her collegiality over the years. I am delighted that she has brought her profound knowledge of medieval dress to bear on our collection and produced such an engaging and informative text. I also thank Rebecca Vera-Martinez, Michael Smith, and Johana Herrera from the Imaging Services Department for the inspired photography for this volume, as well as Christine Sciacca, Kristen Collins, Nancy Turner, Erin Donovan, Martin Schwarz, Lynne Kaneshiro, Stephen Heer, and Ron Stroud from the Departments of Manuscripts and Paper Conservation for their countless hours with the manuscripts in the photo studio. Within the Getty Publications team, Kurt Hauser conceived of the elegant design for this book and executed it with a deep understanding of the beauties of manuscript illumination. I also would like to acknowledge the contributions of Gregory Britton, Beatrice Hohenegger, and Amita Molloy at Getty Publications, as well as manuscript editor Mollie Holtman, for their diligence in making this project a reality.

*Elizabeth Morrison*
*Curator and Acting Head, Department of Manuscripts*
*J. Paul Getty Museum*

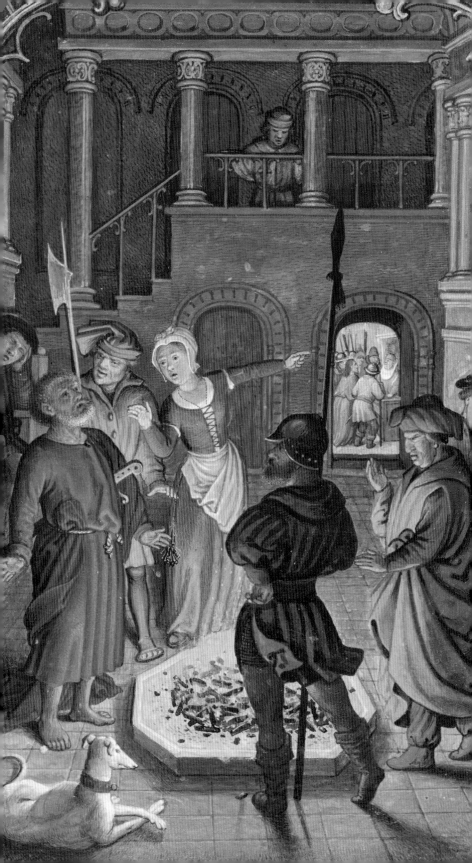

# Introduction

*Our first fathers were dressed in leaves and skins,*
*only to cover the nakedness of their bodies; but*
*gradually, growing with time, men's mischief*
*changed these first outfits in many diverse ways.*
*This happened as much from necessity as from*
*humans' curiosity, as can be seen in Northern*
*countries whose inhabitants have to wear furred*
*garments or heavy cloaks, and in the Southern*
*countries they are naked or wear light clothing . . .*
*But I hope that you will get some pleasure from*
*seeing here the fickleness of our ancestors of old,*
*and [see] that they were more interested in*
*sumptuous garments than in rare virtue.*

—François Deserps to Prince Henry of Navarre, 1562

Clothes are far more than a physical covering for protection from the elements; they can reveal at a glance a great deal about a person. A silk evening gown, a doctor's white coat, cowboy boots—these can all be clues to a person's social status, profession, and sometimes geographical origin. In the Middle Ages, clothing was even more integral to the fabric of society. The production of textiles for clothing, from the keeping of sheep for their wool to the weaving of the finest silks (the latter at a vast expense unimaginable today, except in the world of hand-built sports cars), was a crucial element in the economies of many cities and countries. The trapping of fur-bearing animals to provide fine furs to line the garments of the rich and powerful was carried out on a massive scale, with only the discovery of the New World, and its animals, saving many European species from extinction by the sixteenth century. As will be seen, medieval illuminators developed conventions for depicting both silks and certain furs. Medieval people were highly skilled at reading the meaning of clothing, and their expertise is reflected everywhere in the dress chosen to adorn the figures who appear in illuminated manuscripts.

Illuminators were usually careful to try to maintain clear distinctions of rank in the dress they depicted, especially if they were illustrating stories that involved people of different social classes. The most obvious distinguishing characteristics involved special clothing that royalty and the aristocracy reserved for ceremonies and great formal occasions at court, or when they were on display as powerful figures in front of the general population, as at coronations. The Church placed itself at the top of the social ladder, and although its members were actively discouraged from wearing secular clothing, vestments made of the most extravagant fabrics (found also in secular dress) could be worn for church services. The secular clergy, as well as monks and nuns, were expected to be as distinctive in their dress as anyone else, although sometimes it seems that illuminators settled for vague impressions of monastic dress.

It would be a mistake to regard medieval illuminations as providing an unfiltered, totally realistic depiction of contemporary dress. Wealthy patrons sought in chivalric and romantic tales images that reflected a perfect world, with glorified versions of themselves and even rather too-well-dressed peasants. The medieval mind also accepted the possible intermingling of this physical world and the next, with manuscript owners able to speak to and even touch saints. For such events the host's best finery would, of course, be necessary, both to do honor to the holy visitor and as a reminder to the visitor of the host's status. Most people, however, could never aspire to more than a passing acquaintance with high fashion, in the shape of accessories such as belts or shoes. The poor were rarely picturesque enough to warrant many appearances in the pages of manuscripts; yet peasant dress is sometimes glamorized, with the use of more colorful clothing than would have been natural, even to the extent of including gilded straw hats.

Although it is true that artists of the Middle Ages had little access to or interest in "archaeologically correct" clothing from bygone eras, it is often presumed, quite unjustifiably, that medieval artists always used the dress of their own times for figures

from the past. As this book will show, there gradually arose a system that moved from a fairly general use of contemporary dress for Classical or biblical figures (other than Christ and the apostles) to the use of supposedly historical attire and sometimes a rather subtle mixing of this wardrobe and contemporary clothing (see p. 8).

In looking back at the past, medieval writers had a tendency to assume that things had been better in the good old days, and that clothing, unlike that worn whenever any given writer was complaining about his contemporaries, had been simpler and that it had thus made people, especially women, better. Yet the images produced in manuscripts in an attempt to depict the past included clothing that became, like fashionable clothing, ever more elaborate.

Unlike the modern-day creators of historical dramas, who are sure to irritate someone in nearly any field of knowledge by including gaffes ranging from inappropriate speech patterns to incorrect costume, the medieval illuminator was not faced with a critical audience with access to the vast stores of information available today.

If we can suspend our disbelief and accept the stylized nature of many medieval illuminations, we can see that their creators have left us with some wonderfully lavish images of the clothing that people wanted to wear, and of the clothing they imagined previous ages had worn.

# DRESSING FOR THE MOMENT

*But who could understand the excessive inventions added to clothes? New clothes must lay claim to something novel, so that the change of shape may declare the garments to be new.*

—ALEXANDER NECKAM, LATE TWELFTH CENTURY

## STUFFS OF CLOTHING

Dress in the Middle Ages was made of three basic natural materials—linen, for underwear; wool, for a wide variety of garments; and silk (fig. 1), which various cities and countries at various times tried to ensure was worn only by the upper classes and privileged members of the middle classes as it became increasingly sought after. Silk is difficult to identify in manuscript illuminations, unless the fabric is patterned or is in costly colors such as red and purple or is embellished with gold edgings (fig. 2). Sometimes the rich and powerful decorated their clothing with embroidery that might incorporate precious stones, although these are rarely seen in detail in manuscripts, perhaps because the images were already too small to allow for what would have become tiny items in them. As buildings were drafty and difficult to heat, winter clothes were often lined with furs and skins. The clothing of the lower classes drew on a much more limited range of fabrics, dictated by practicality and cost. Even colors, especially crimson, could be forbidden to them and restricted to the upper classes. At the lowest social levels, rough, undyed woolens were worn over coarse linens.

1
**Fragment of Silk Cloth**
Italy, 1200s or 1300s
Chicago, Art Institute of
Chicago, 1958.521

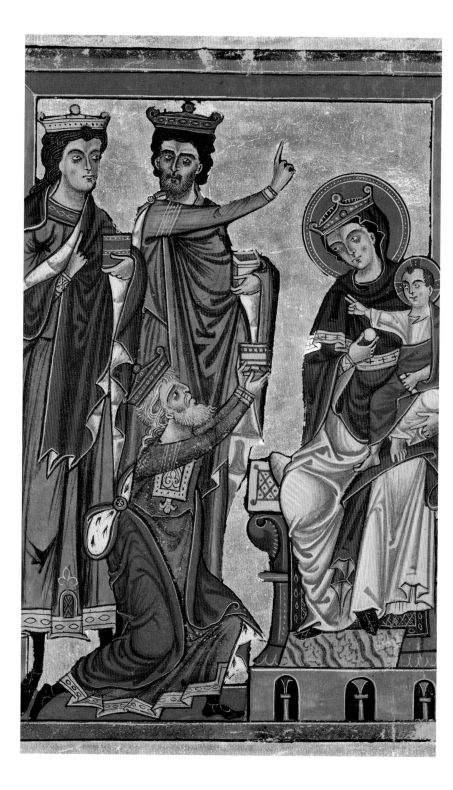

FASHION IN THE MIDDLE AGES

**2**
**The Adoration of the Magi**
Miniature from a psalter
Würzburg, ca. 1240
JPGM, Ms. 4, leaf 2

Gold trimmings, especially when worn with purple, as seen here on the two Magi, create the impression of silk tunics. Two of the cloaks are lined with the most popular status-conferring fur, the gray and white winter squirrel fur known as miniver, here stylized into gray-blue hat-like shapes against white. The cloak of the kneeling Magus is lined with ermine, the winter coat of a member of the weasel family, which was reserved for royalty and other high social ranks.

---

**3**
**Calendar Scene for August:**
**Men Reaping**
Psalter
Flanders, ca. 1250
JPGM, Ms. 14, fol. 6v

In contrast to the lavish materials and furs of the upper classes, the clothing of these peasants at work is an accurate reflection of their vastly inferior social status and means. One harvester has stripped down to his linen underpants, though his companion still wears his woolen stockings and tunic. Straw hats were worn outdoors by all ranks in the summer.

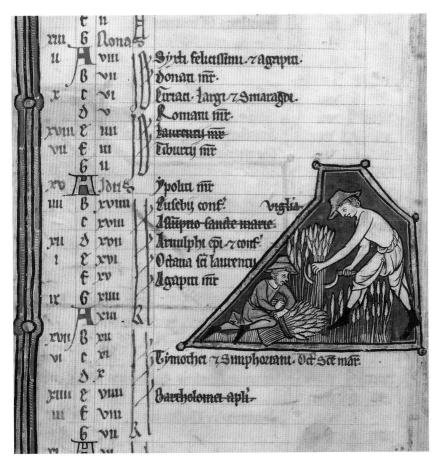

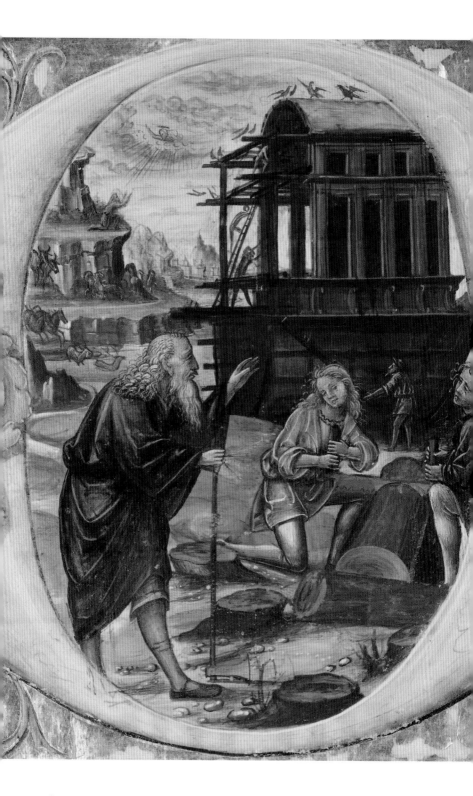

FASHION IN THE MIDDLE AGES

**4**
**Initial *D*: Noah Directing the Construction of the Ark**
Master B. F.
Cutting from an antiphonal
Lombardy, ca. 1495–1510
JPGM, Ms. 56, recto

Although elements fashionable at the end of the fifteenth century appear in the square-toed shoes of Noah and in the gown lapels and frilled shirt neckline of the workman in the center, all the figures wear dull colors suggestive of undyed sheep's wool, which could be used to create fabrics in hues ranging from near-black via brown to gray and off-white.

---

**5**
**Lydia Ordering the Death of Her Sons**
Loyset Liédet
Leaf from the *Histoire de Charles Martel*
Bruges, 1467–72
JPGM, Ms. Ludwig XIII6, leaf 12

Wool was made into every kind of outer garment, from stockings to hoods to gowns. The most valued woolen material, called scarlet (a word that originally denoted a high-quality woolen fabric), was sometimes dyed red with an extremely expensive, insect-based dye called kermes (whence came our word "crimson"). The relatively unassuming red gown of the man just left of center is probably to be understood as being made of scarlet, in contrast to the two red and gold-highlighted gowns at front right. At this time a yard of scarlet would have cost a mason fifteen days' wages.

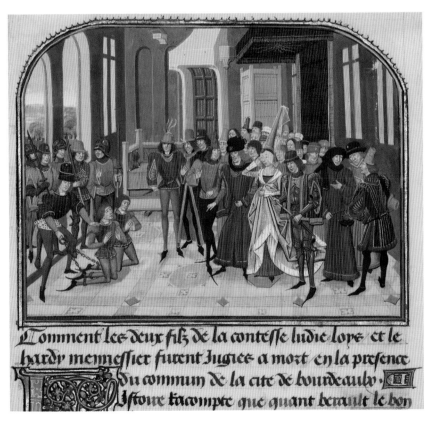

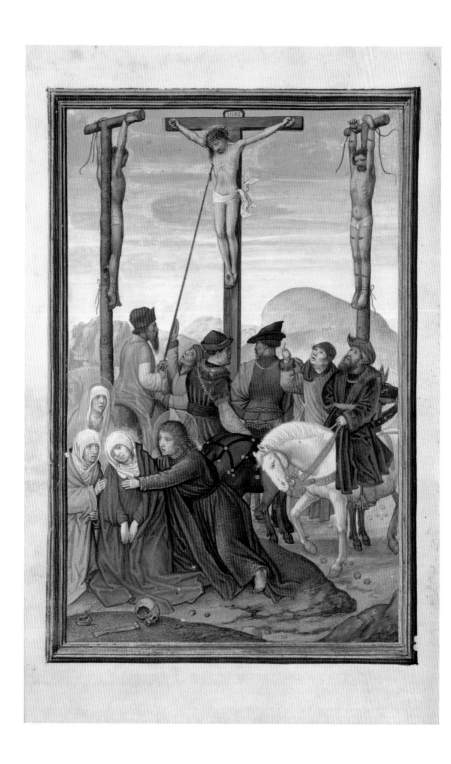

FASHION IN THE MIDDLE AGES

**6**
**The Piercing of Christ's Side**
Simon Bening
Prayer Book of Cardinal
Albrecht of Brandenburg
Bruges, ca. 1525–30
JPGM, Ms. Ludwig IX 19,
fol. 302v

Velvet first appeared, as an extremely expensive silk fabric, in the late 1200s, although manuscript illuminators seem not to have depicted it much before 1450. It is recognizable, as here in the man's blue gown, from rather smudged areas of color, caused by an attempt to depict the effects of light hitting the fabric's pile and the very dark shadows to be found in its folds.

Charles the Bold, Duke of Burgundy, is shown here in cloth of gold, whose meandering crimson floral pattern would have been woven as velvet, against a background of gold thread. At this time, gold thread was usually made by wrapping strips of silver-gilt foil around a core of silk thread. Cloth of gold was the ultimate status symbol in clothing, and Charles the Bold made great display of it in his public appearances. Many found the cost of dressing fashionably at his court ruinously expensive.

The fifteenth century saw remarkable changes in silk textiles and patterns. This garment used in church services is made of cloth of gold with patterns worked in two heights of crimson silk velvet within which are small clusters of gold thread loops. Embroidered images of saints, worked separately, have been applied on top of the cloth of gold. Aliénor de Poitiers, whose mother had been a lady-in-waiting to Charles the Bold's

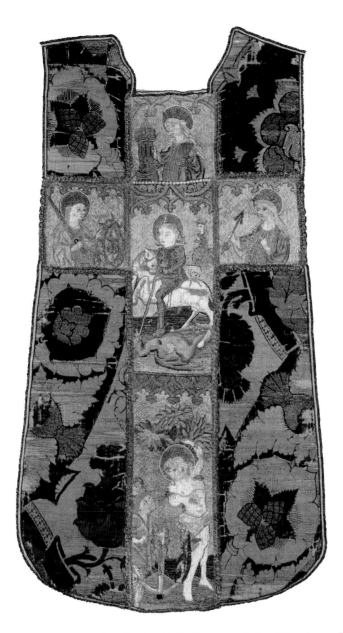

mother, felt that distinctions in rank should be observed in the wearing of the different types of cloth of gold. According to her book on etiquette, the type we see here, with its loops, should be worn only by kings and great princes (see fig. 7). The church often received gifts of such textiles, either as new fabric or as discarded, once-fashionable clothes, to be made into vestments, like the chasuble here.

# EXPERIMENTS IN TAILORING

After centuries of people sewing simply cut, T-shaped tunics for themselves, in the eleventh century professional tailors began to experiment with ways of making clothing fit more closely. In the twelfth century clothing was often extremely awkward to wear, being tight around the body, with sleeves that were both too long and too loose (figs. 9, 10). In the thirteenth century armholes were very tight, and the hems of clothing were often slashed (figs. 11, 12). Sleeveless overgarments were introduced, and in Spain a fashion for deep "armholes" (fig. 13) developed rapidly. In the fourteenth century, sleeves on overgarments became progressively shorter—from the wrist to the elbow—while developing ever-longer "tails" that hung from the backs of the arms; under-sleeves would be buttoned along the forearm (fig. 17).

In about 1360 the hoods that had been standard head coverings for men also shrank to a point where they seemed to be in danger of strangling their wearers; but around the same time the center-front opening was introduced into men's garments, making clothing easier to put on and take off and providing an opportunity for the lavish use of buttons (fig. 18). Joining the sleeve comfortably to the body of a garment remained a problem into the early fifteenth century, but thereafter few serious difficulties remained in the construction of fashionable clothing.

9
**Calendar Scene for
September: Virgo**
Stammheim Missal
Hildesheim, ca. 1170s
JPGM, Ms. 64, fol. 7v

Too-long, and hence crinkled, under-sleeves were so familiar
to this twelfth-century artist that he incorporated them into the
clothing of figures such as the Creator, above, and Abraham,
to the right. The fashion for long, trailing elements is shown in
Virgo's braids and in the long, narrow cuffs on her sleeves (see
fig. 9) and the outer sleeves of the personification of wisdom
(see fig. 10, center). Wisdom's great collar and long front band
are influenced by practices in the contemporary Byzantine
world, where Holy Wisdom, not the Holy Ghost, was the third
person of the Trinity. In the figure of David (at left), note that
the artist has neglected to alter the alignment of the shield
shapes of the miniver fur lining at the hem of his cloak as it
comes up over his arm.

10
**Wisdom**
Stammheim Missal
Hildesheim, ca. 1170s
JPGM, Ms. 64, fol. 11

**11**

**David Hears of the Treachery of His Son Absalom and Flees Jerusalem; Absalom Consorts Publicly with His Father's Concubines**

Leaf from the Morgan Picture Bible

Northern France, ca. 1250

JPGM, Ms. Ludwig I 6, recto

Here (see also detail on p. 22) we see two varieties of squirrel fur used as linings: the usual gray-blue and white miniver (seen in the king's cloak at upper left and in the cloak hanging at upper right), and the rarer autumn variant, in rusty red, called strandling (within the seated group at top right, it is visible in the cloak of the woman on the left and in that of Absalom in the center). As can be observed here, the armholes of tunics tend to look uncomfortably tight and wrinkled. The women's headdresses are equally constricting. If a second tunic is worn on top, it is often sleeveless, with a much larger armhole, as in the examples hanging from the clothes rack and worn by the woman on the extreme right. If it has short pendant sleeves, it is often split up the front from the hem (seen on the male figure in blue at the center of the lower left compartment).

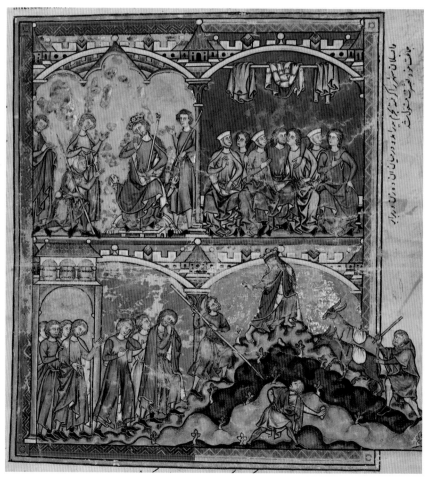

| xi | A | uiii | | Theodofie virg̃. |
| | B | iii | | Ambrofij epĩ |
| xix | c | ii | | |
| viii | D | nonas | | |
| xvi | e | viii | | |
| v | f | vii | | |
| | g | vi | | |
| xiii | A | v | | Waldecrudis virg̃. |
| ii | b | iiii | | |
| | c | iii | | leonis p̃p. |
| x | d | ii | | |
| | e | idus | | Eufemie virg̃. |
| xviii | f | xviii | | Tiburcij et valeriani m̃r. |
| vii | g | xvii | | |
| | | xvi | | |
| xv | b | xv | | Iuliani p̃p. |
| iiii | c | xiiii | | |
| | D | xiii | | |
| xii | e | xii | | |
| i | f | xi | | |
| | g | x | | |
| viiii | A | viiii | | Georgij m̃r. |
| | B | viii | | |
| xvii | c | vii | | Marci eũangl̃ |
| vi | d | vi | | |
| | e | v | | |
| xiiii | f | iiii | | vitalis m̃r. |
| iii | g | iii | | |
| | A | ii | | |

**12**

**Calendar Scene for April:**
**A Man Holding Branches**

Psalter

Flanders, ca. 1250

JPGM, Ms. 14, fol. 4v

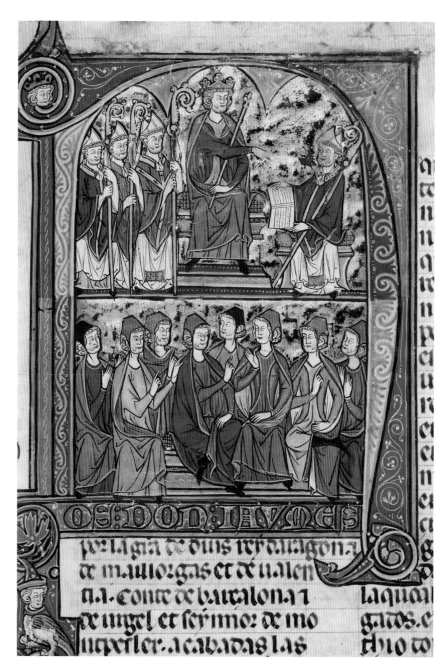

**13**
**Initial *N*: Vidal de Canellas Offering**
**His Text to King James I of Aragon**
*Feudal Customs of Aragon*
Northeastern Spain, ca. 1290–1310
JPGM, Ms. Ludwig XIV 6, fol. 1

FASHION IN THE MIDDLE AGES

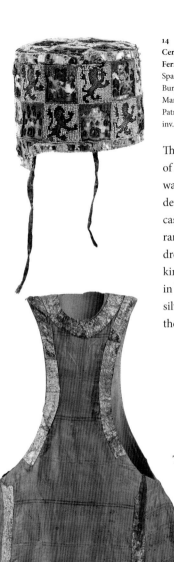

**14**
**Ceremonial Cap of the Infante**
**Fernando de la Cerda**
Spain, before 1275
Burgos, Monastery of Santa
María la Real de Huelgas,
Patrimonio Nacional,
inv. 00650523

The infante Fernando, a great-great-grandson
of Enrique I (see fig. 15) and heir to Castile,
was buried in an outfit covered in the heraldic
devices seen here, the lions of León and the
castles of Castile, that thereby proclaimed his
rank. Caps like this featured in Iberian male
dress for many years (see the counselors of the
king in fig. 13). The embroidery was executed
in blue glass beads, grains of coral, pearls, and
silver and silk threads. The gold band around
the base has sapphires and garnets added to it.

**15**
***Pellote* of Enrique I of Castile**
Spain, by 1217
Burgos, Monastery of Santa
María la Real de Huelgas,
Patrimonio Nacional,
inv. 00650540

This garment comes from the tomb of King
Enrique I of Castile. It shows the very early
adoption in the Iberian Peninsula of
sleeveless garments with huge armholes
(see fig. 13). It was made in Andalusia
of taffeta and dyed crimson with the
expensive dye known as kermes,
made from insects. The gold thread in
its horizontal stripes is 24 carat, and
the garment was lined with rabbit
fur. Gilded leather forms the bands
at the neck, the armholes, the side
front, and the slashed hem.

16

**Initial S: Parents Seeking
Advice on the Financial
Entitlements of Their Children**
*Feudal Customs of Aragon*
Northeastern Spain,
ca. 1290–1310
JPGM, Ms. Ludwig XIV 6,
fol. 209

While some Spanish women wore headdresses like those seen
in France (figs. 11, 28), others wore tall arrangements of narrow
overlapping strips of cloth. Spanish women wearing this sec-
ond type of headdress were unusual in that they left so much
of their hair loose and on display.

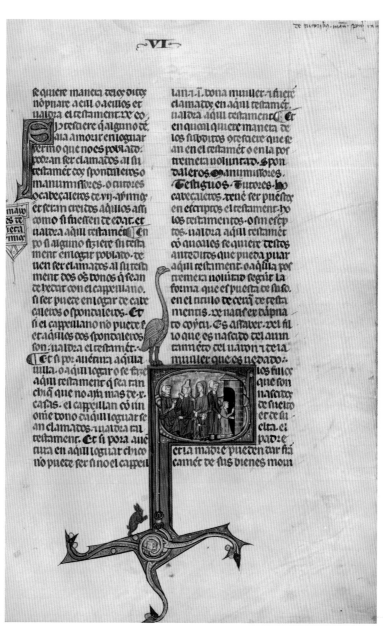

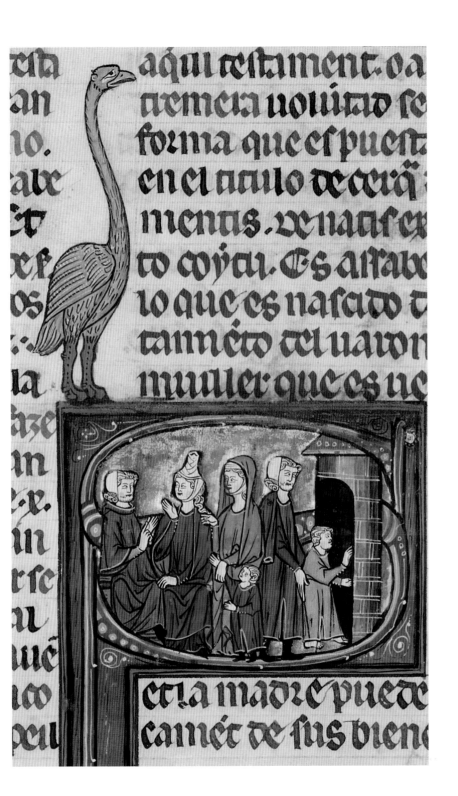

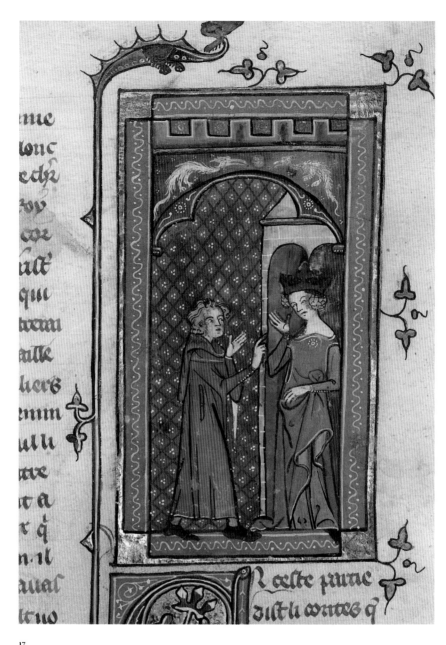

**17**
**Gaheriet Speaking to Queen
Iseut about Tristan**
*Romance of Tristan of Leonois*
Paris, ca. 1320–40
JPGM, Ms. Ludwig XV 5,
fol. 306v

The queen's sleeveless, open-sided overgarment (a *surcote ouverte*) is currently fashionable, but by the beginning of the next century it will have been transformed into a piece of clothing worn by noblewomen wishing to declare their rank (fig. 40).

18

**Alexander the Great with
His Generals**
Master of Jean de Mandeville
Guyart des Moulins,
*Historical Bible*
Paris, ca. 1360–70
JPGM, Ms. 1, vol. 2, fol. 138

The dying Alexander the Great is in a state of undress (but still crowned) as he sits up in bed, but his generals are shown in dress fashionable in fourteenth-century France. Padding and pinching give them their hourglass torsos. By 1365, short garments and long-toed shoes like the ones seen here had become so widespread that they were forbidden to the French clergy, who were expected to wear the clothing appropriate to their calling. In 1366, the French king prohibited the production of long-toed shoes and stockings, in the vain hope that by cutting off the source of supply of the latest excesses of fashion, he could eradicate the fad itself. But fashion has almost always proved more ingenious than the law, as governments have rarely controlled the actual production of clothing.

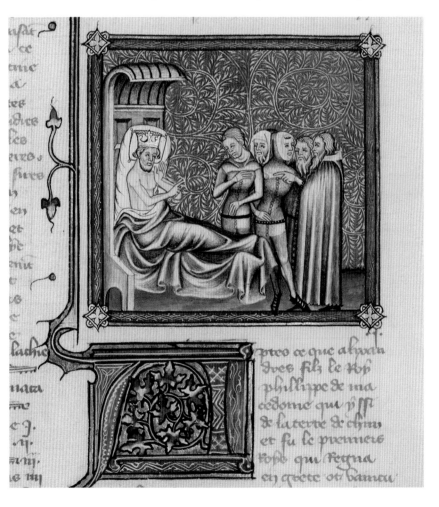

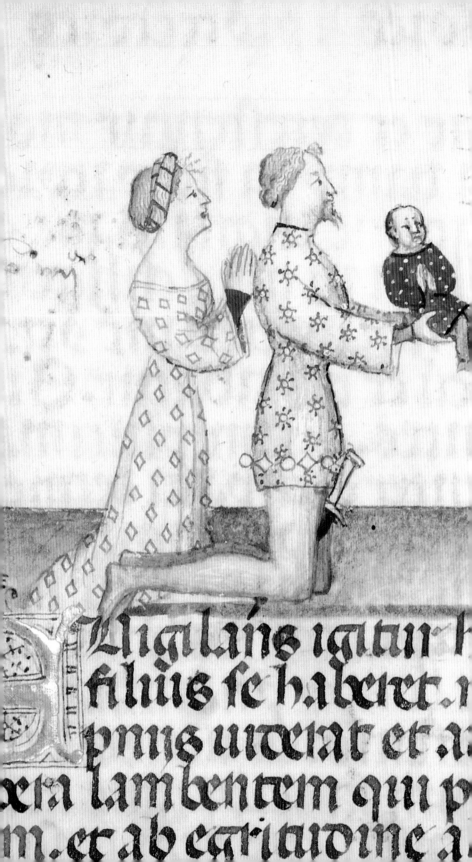

Uigilans igitur h
filius se habeat. n
pruis uideat et a
ta lambentem qui p
m. et ab egritudine a

A round 1400 there was considerable convergence in the styles of clothing worn across western Europe, but as the century progressed national and regional elements became more obvious. At the start of the century a basic wardrobe item for women was a sleeved garment (*cote hardie* in French) that clung tightly around the upper body and revealed a great deal of the shoulders (fig. 20). It could have narrow sleeves or share the great trailing ones of the most elaborate piece of clothing, the high-collared and wide-sleeved gown known in France as the *houppelande* (figs. 19, 32). *Houppelandes* could have slashed edges (dagging) to their sleeves (fig. 19) and, when worn by men, at their hems (see fig. 20). Middle-class and working-class women in France would wear black, red, or pink hoods open under the chin and turned back at the hairline (fig. 22). In Italy the climate encouraged the wearing of fewer heavy overgarments, and stockings with leather soles rather than shoes or boots; married women there were less likely to cover their hair.

By 1470 the upper classes all across western Europe were increasingly wearing Italian silks, but national and regional differences in clothing styles had also become well established, particularly in the dress of women; in Italy and Germany especially, their appearance could vary markedly between cities. The upper classes in France and Flanders, probably because they shared a French-speaking culture, dressed alike despite living under different rulers. Illuminators, however, often depicted only the styles of dress they knew from everyday life and artistic practice, even if the text illuminated derived from another country (see fig. 23, a text by an Italian that was illuminated in France). By the end of the century, velvet cloth of gold (velvet patterns against a background of gold threads), sometimes with loops of gold thread worked into areas of the velvet, had become standard as the "best" attire for the upper classes, wherever they lived.

**19**
**A Scribe and a Woman**
Rudolf von Ems,
*World Chronicle*
Regensburg, ca. 1400–1410
JPGM, Ms. 33, fol. 3

Both figures here wear a version of the *houppelande*, a garment with a high collar and wide sleeves, although the scribe's gown is made of far less elaborate fabric and has smaller sleeves, closed like bags. Women, as here, tended to cinch their *houppelandes* under the bust, whereas men's were belted closer to the natural waistline. The woman's very high rank is marked by the ermine lining her huge sleeves and by the lavish use of gold in the fabric of her *houppelande*, which is perhaps meant to recall the phoenix-like birds incorporated in some contemporary Italian silks.

**20**
**Uriah at David's Table**
Rudolf von Ems,
*World Chronicle*
Regensburg, ca. 1400–1410
JPGM, Ms. 33, fol. 192

This illuminated manuscript was produced in what is now Germany; thus, the image appropriately reflects the penchant of German women of the period for headdresses made from layers of veils that had frilled edges, worn with garments that bear comparison with contemporary French ones. The woman here wears a sleeved garment (*cote hardie* in French) that clings tightly to the upper body and reveals a great deal of the shoulders and décolletage. The servants here wear fashionably cut dress, with the one on the left in an elaborate version of *mi parti*.

chunikleicher wirtschaft
Daz in der starchen wemes elpast
zw semes leibes let lieb trib
vnd er dy nacht pei ir belib
Daz auf daz er ir pflag
ze weib vnd pei ir lag
vnd da von anzweifels wan
Daz chint ze chint must han
Daz si von daindes leib trug
dwie des mar dann genug
Daind versucht an semen leib
Dy vart besirt er nie sem letweib
wan er si wolt meiden

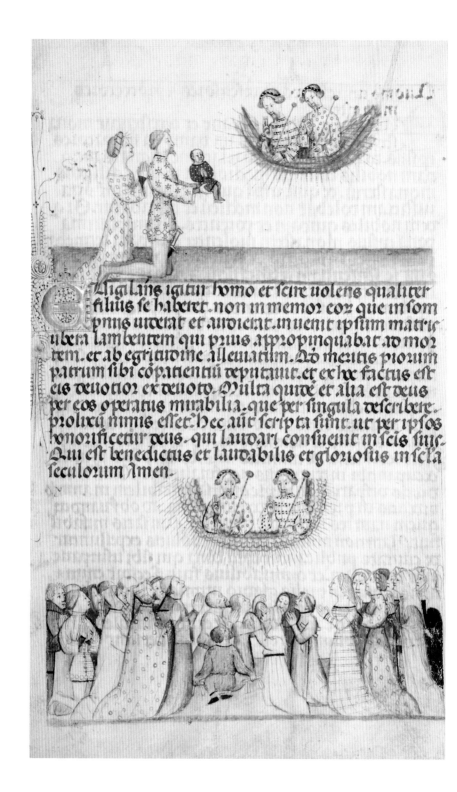

Eligi lins igitur homo et scire uolens qualiter
filius se haberet. non in memor cor que in som
pnus undeat et audierat. in uenit ipsum matris
ubera lambentem qui prius appropinquabat ad mor
tem. et ab egritudine alleuiatum. Ad meritis piorum
patrum sibi compatientiu deputauit. et ex hoc factus est
eis deuotior ex deuoto. Multa quidem et alia est deus
per eos operatus mirabilia. que per singula describere.
prolixu nimis esset. Hec aut scripta sunt. ut per ipsos
honorificetur deus. qui laudari consueuit in scis suis.
Qui est benedictus et laudabilis et gloriosus in secla
seculorum Amen.

FASHION IN THE MIDDLE AGES

**21**
**A Crowd of Lay Worshippers Giving Thanks to Saints Aimo and Vermondo**
Attributed to Anovelo da Imbonate
*Legend of the Venerable Men Aimo and Vermondo*
Milan, ca. 1400
JPGM, Ms. 26, fol. 9

Many of the garments of the wealthier citizens of Milan, pictured here venerating the local heroes Aimo and Vermondo, are to be read as examples of patterned silks. Because Italy provided western Europe with most of the silks used in upper-class clothing, it is far more common to find representations of these fine fabrics in manuscripts created in Italy than in those from northern Europe.

**22**
**A Patron Presented to the Virgin and Child**
Workshop of the Boucicaut Master
Book of hours
Paris, ca. 1415–20
JPGM, Ms. 22, fol. 137

The French poet Eustache Deschamps (d. ca. 1406) criticized contemporary middle-class women for pining after the books of hours and the splendid clothes owned by the nobility. Though this middle-class woman possesses her book of hours, she has not forgotten how her standing demands that she dress in a narrow-sleeved *cote hardie* and lower-class hood (compare to fig. 34).

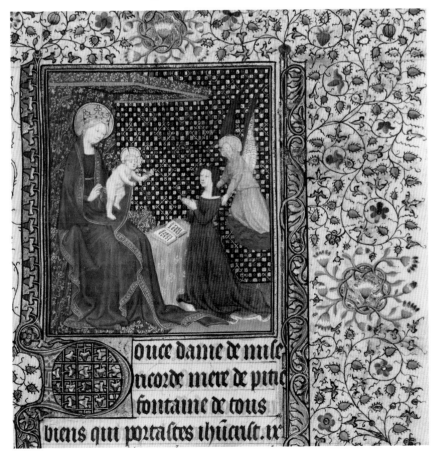

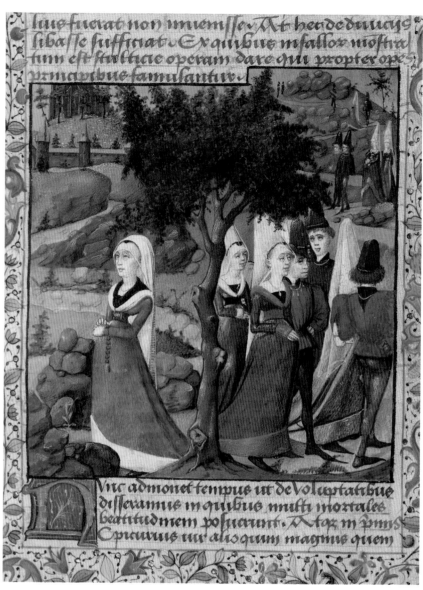

**23**
**Young Men and Women Outdoors**
Aeneas Silvius Piccolomini,
*The Story of Two Lovers*
France, ca. 1460–70
JPGM, Ms. 68, fol. 8

The tall, steeple-like bonnets of the women in this image are counterbalanced by their long trains. Men, too, had tall hats, and long toes on their shoes or boots. They also slashed their gown sleeves to reveal the sleeves of their doublets and even their shirts through the slits, as seen on the garment worn by the man at right. In England in 1463, the wearing of short tunics that revealed the male buttocks (like the garment on the far right) was restricted by law to the upper classes.

**24**
**Tondal Appears to Be Dead**
Simon Marmion
*Visions of the Knight Tondal*
Ghent and Valenciennes, 1475
JPGM, Ms. 30, fol. 11

Franco-Flemish fashions changed relatively quickly in the 1470s, especially for men, who dispensed with belts and thereby lost the hourglass shapes seen in figure 23. It was briefly fashionable to wear hats attached to tails, a form that derived from earlier hoods (compare to fig. 5). Another version of women's steeple-shaped headdresses, seen here, involved a narrow cone-shaped cap inserted into a shorter, open-topped cap of black silk, with front flaps. The anachronistic dagged sleeves of the recumbent Tondal are meant to imply that the scene takes place in the past.

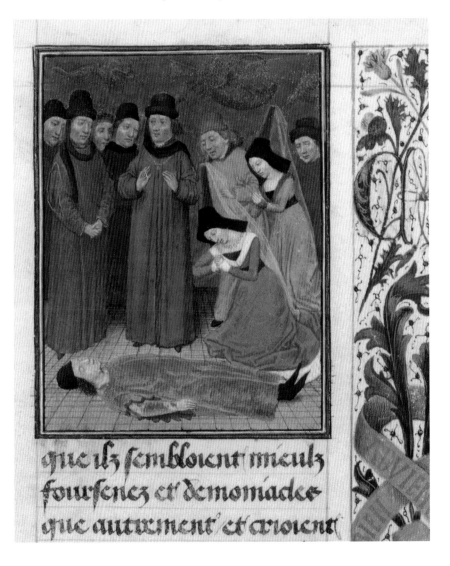

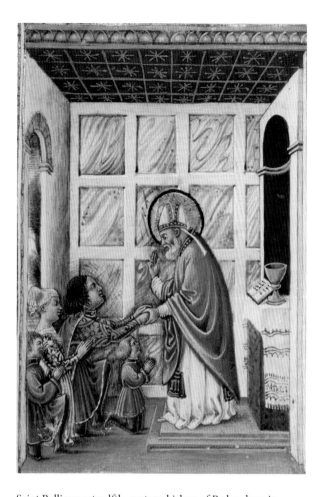

25
**Saint Bellinus Celebrating Mass before Andrea Gualengo and Orsina d'Este**
Taddeo Crivelli
Gualenghi-d'Este Hours
Ferrara, ca. 1469
JPGM, Ms. Ludwig IX 13,
fol. 199v

Saint Bellinus, a twelfth-century bishop of Padua, here in vestments worn while celebrating Mass, takes the hands of Andrea Gualengo, who wears a typically Italian outfit: a doublet with puffed upper sleeves (in this case made of crimson cloth of gold); tights, which would have had integral soles; and an open-sided garment called a *giornea* (here in purple). His wife's hair is dressed in Ferrarese style, with "horns" at the sides of the head under a short, filmy veil. Her cloth-of-gold sleeves are typical of the contrasting, detachable sleeves worn by Italian women at this date. Typically Italian, too, is her low back neckline.

**26**
**The Prodigal Son at the Brothel**
Workshop of Diebold Lauber
Rudolf von Ems,
*Barlaam and Josaphat*
Hagenau, 1469
JPGM, Ms. Ludwig XV 9, fol.
106

Considering that central European men often drew admiring comments from foreigners because of the length and beauty of their hair, it is significant that the Prodigal Son lets himself become quite unkempt in poverty; as further proof of his degradation he loses the fine plumed circlet (another central European hallmark) he wore on his head in the first scene, at far left. The harlots' hairstyles reveal a fondness for braids in German women's hair fashions. As with the Franco-Flemish women's gowns, German women's gowns fit tightly around the arms and upper body; but they differ in having pleated areas under the bust, and no deep belts.

Fashion has always been an easy target for criticism. In the hierarchical society of the Middle Ages, where people automatically read outward signs such as clothing, following the changes in fashion indicated that one was fickle and shallow. When women wore new styles, especially if those styles could be deemed seductive, misogynists (chiefly clerics) claimed that this "proved" that women were bent on snaring men for the devil. The lay authorities worried increasingly that too many people were acquiring access to fashion and expensive textiles, thus imperiling the social order, as defined through clothing, and economic stability, especially if the fabrics had to be imported. Sometimes those whose occupations prevented them from retaining their dignity while wearing fashionable dress are shown as being ugly as well (see fig. 27).

27
**The Emperor Domitian Speaking to Saint John the Evangelist and Saint John in a Vat of Boiling Oil**
Dyson Perrins Apocalypse
England, probably London, ca. 1255–60
JPGM, Ms. Ludwig III 1, fol. 1

At a time when men's stockings came a little above the knee, and vast underpants or shirts were tucked into the tops of them, short clothing, especially when fashionably split, created the risk of indecent exposure for those obliged to perform physical labor, like the guard at the center beside Saint John. The emperor Domitian, who has ordered Saint John's torment, is able to remain decently covered, despite sitting in the cross-legged pose used by royal and other important figures at this time.

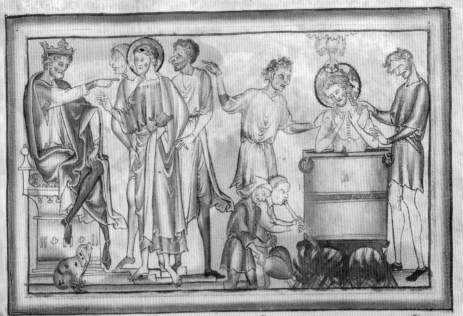

tiſſimo ceſari ⁊ ſemp̄ au
guſto domiciano p̄conſul
epheſiox̄ ſaluten. floꝛifica
mꝰ gloꝛie uıe ꝗn qꝫ
ur nomıne Johanneſ ex
genere hebꝛeoꝝ in aſıam
uenıenſ ⁊ pꝛedicanſ ıĥm xp̄m crucıfixıl
affirmat eum uerum deum ⁊ dei filıum
ēē. Culturam aı̄t immortaliſſimoꝝ deoꝝ noꝛ
euacuat ⁊ templa uenerãda ab anteceſ
ſoꝛibꝰ nr̄ıs conſtructa funditꝰ euertere
feſtinat. Contrarıuſ itaꝗ ihe exiſtenſ ut
magꝰ ⁊ ſacrilegꝰ uꝛo imperiale edicto?
ſuıs magıcıs artıbꝰ ⁊ pꝛedicationıbꝰ om
nem pene populum urbıs epheſıne ad
culturam hoıīſ crucıfixı ⁊ moꝛtuı co
uertıt. Hoſ aũt zelum halenteſ erga
culturam immoꝛtalıum deoꝝ tribunalıbꝰ
nr̄ıs pꝛeſentatum admonuımꝰ blande
tııſ ⁊ terroꝛıbꝰ ut uıꝛ ueſtrı edictum ın

perıtı xp̄m ſuum abnegaret atꝗ̄ dııſ
omnipotentıbꝰ grata libamına offerret
Sᵭ eum nulla ratıone ıſta ſuadere po
tuıſſemuſ · hoſ apıceſ uıꝛ poteſtatı dı
reximuſ · ut quıcqͦd maıeſtatı uıe pla
cuerıt de eo fıerı notıficetıſ · Statım ut
legıt epl̄am mıſımuſ domıcıanuſ ſcripſıt
p̄conſulı uꝛ ſanctum Johannē uınctum
cathenıſ ab epheſo ad urbem adꝺuceret
romam. Tunc p̄conſul ſecundū imperale
pꝛeceptum beatıſſımū Johannem apl̄m
cathenıs uınctum romam ſecum adduxıt
⁊ ceſarı domıcıano eıuſ aduentum nuncıa
uıt. Indıgnatuſ autē crudelıſſımus domı
cıanuſ p̄conſulı iuſſıt ut ante poꝛtam que
latına elıuır ı̄ ᵱſpectu ſenatuſ in feruen
tı dolıo ſᵭ Johanneſ deponeretur. prıuſ
tı flagellıs cederetur. Quod ⁊ fꝛm z̄ Uñ p̄
gente eum grā dei tam ılleſus exııt quam
ımmunıſ a coꝛruptıone carnıs extıtıt

oleı

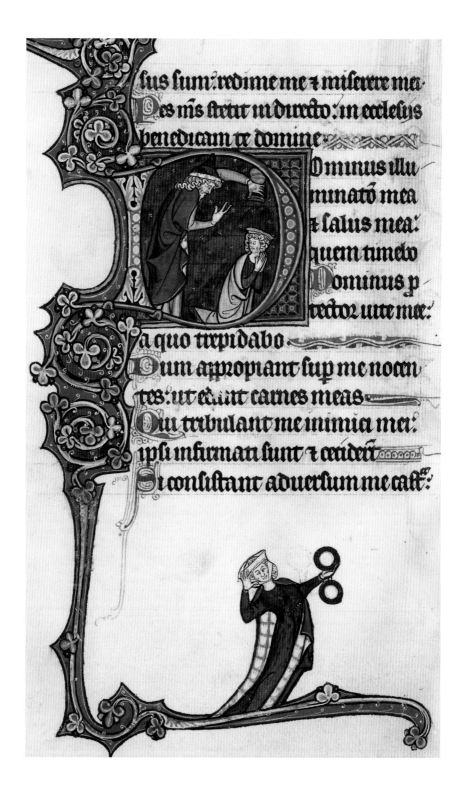

fus fum:redime me ⁊ miferere mei
Pes mis ftetit in directo:in ecclefijs
benedicam te domine:

Ominus illu
minatio mea
⁊ falus mea:
quem timebo
Dominus p
rector uite mee:

a quo trepidabo
Dum apropiant fup me nocen
tes:ut edant carnes meas
Qui tribulant me inimici mei:
ipfi infirmati funt ⁊ ceciderūt
Si confiftant aduerfum me caft:

**28**
**Initial *D*: The Anointing of David; A Woman with a Mirror (border)**
Bute Master
Bute Psalter
Northeastern France,
ca. 1270–80
JPGM, Ms. 46, fol. 32v

The woman depicted here in the lower border is a complex response to the words of Psalm 27, which accompanies this image, and to the effects and pitfalls of fashion. Women holding mirrors were used as symbols of vanity; and she may be stretching out one hand to adjust her headdress in the mirror. She may, however, equally well be turning away from the mirror while straining to hear the words of the psalm: "One thing have I asked . . . to behold the beauty of the Lord . . . When thou didst say, Seek my face; my heart said to thee, Thy face, Lord, I shall seek." Not surprisingly, contemporary literary evidence suggests that women in such headdresses found it difficult to hear properly.

**29**
**Initial *D*: The Fool**
Mahiet (?)
Breviary
Paris, ca. 1320–25
JPGM, Ms. Ludwig IX 2, fol. 33

The psalm that accompanies this image begins, "The fool has said in his heart, 'There is no God.'" Many of the figures in this manuscript wear quite simple clothes, but the fool, as proof of his lack of judgment, has succumbed to fashion, in this case "tails" on his sleeves.

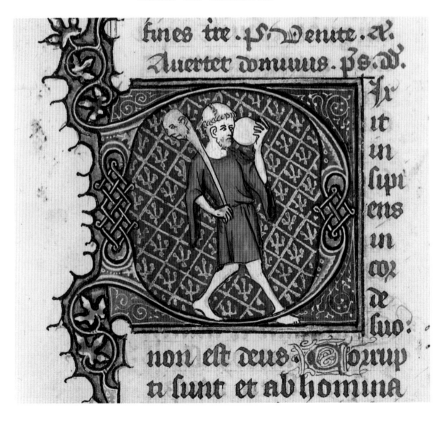

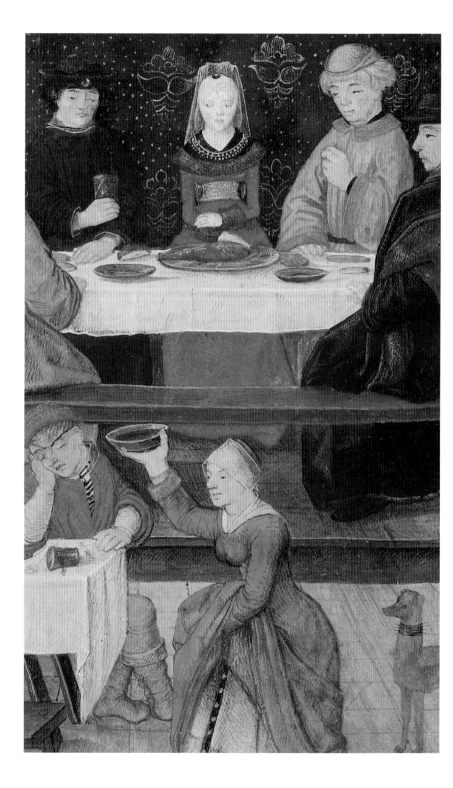

FASHION IN THE MIDDLE AGES

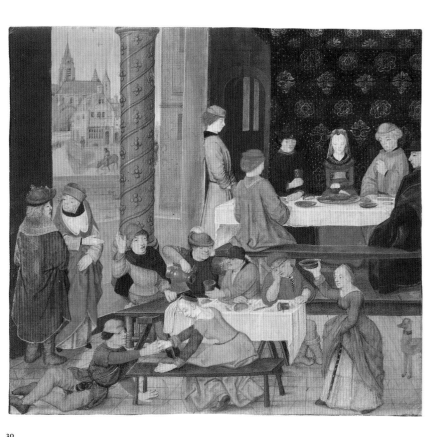

**30**
**The Temperate and the Intemperate**
Master of the Dresden Prayer Book
Cutting from Valerius Maximus, *Memorable Deeds and Sayings of the Romans*
Bruges, ca. 1475–80
JPGM, Ms. 43, recto

On the left stand two first-century figures: the emperor Tiberius, with crown and beard (the latter marking him as an "antique" figure), and the writer Valerius Maximus, with the wide, fur-lined cowl of medieval writers and scholars. Everyone else wears Flemish dress of the later 1470s. The upper classes, at the right rear, include a lady so temperate that she has eschewed the very tall headdress of high fashion; in a piece of irony that was probably lost on the artist as he was so used to depicting them, her ultra-thin arms, perhaps the result of her temperance, are extremely fashionable. The intemperate lower-class women in the foreground, by contrast, are much plumper, and they display varying amounts of underclothing—the woman approaching the table holds up her gown to reveal the skirt of her underdress, while the other woman wears only her underdress and false sleeves. Such an outfit may mean that she is a lady of easy virtue.

# CLOTHING A TALE: *Romance of the Rose*

T he *Romance of the Rose* was one of the most popular texts in the Middle Ages. It is the account of a dream in which the narrator goes in search of a rose (that is, in search of sexual conquest) with the help or the hindrance of various personifications, such as Wealth, Fair Welcome, and Shame. The original text was composed in two stages in the thirteenth century; it includes early attempts to convey the idea of dressing stylishly (as opposed to just fashionably). The illuminators of later manuscript copies paid varying degrees of attention to its descriptions of clothing. Although the illuminators of this manuscript were working with a limited color scheme, and they were not always consistent in the clothing they gave the same character in different scenes, on the whole they tried to take some account of the text. Incongruities that may worry the more archaeologically aware viewer today seem to have caused little concern among those who used this and similar volumes—what viewers were offered was a criticism of those who rejected stylish (as opposed to merely fashionable) clothing, and a view of their own world at its most elegant.

*Romance of the Rose* by Guillaume de Lorris and Jean de Meun
Paris, ca. 1405
JPGM, Ms. Ludwig XV 7

**31**
**Female Personification of Avarice, fol. 2**
Avarice is one of the undesirable, simply dressed, personifications excluded from the garden in which the narrator will shortly meet those who devote themselves to the pleasures of aristocratic youth, including dressing stylishly. In the text, she proved her reluctance to spend money on clothes by wearing things that she had had for twenty years, including an old patched *cote* (under-dress) that looked as though dogs had torn it. The cloak that hung on a pole beside her was lined not with (fashionable and expensive) miniver but with (cheap and old-fashioned) heavy lambskin.

**32**

**Female Personification of Idleness and the Narrator, fol. 4v**

According to the text, Idleness strikes the narrator as someone whose work is done when she has dressed and adorned herself. The text states that she should be wearing a *cote* (under-dress) of rich green cloth of Ghent, sewn tightly around her, a gold-embroidered chaplet with roses above it on her head, and a pair of white gloves to keep her hands white. Here the tightly fitting dress that Idleness wears is the body-revealing *cote hardie* (a version of the *cote* for wear as an outer garment). Its huge sleeves indicate the character's lack of manual occupation; her hands are partially protected by over-long under-sleeves. The narrator, shown addressing her at the door, is dressed in an *houppelande* in which the selective use of color draws our attention to the strips of dagging inserted into the back seam of the sleeve. Dagging can be found in this position around 1400 and may be placed here in this scene in an attempt to relate to the text's description of how, when the narrator first got dressed, he had to sew up his sleeves in a zigzag stitch.

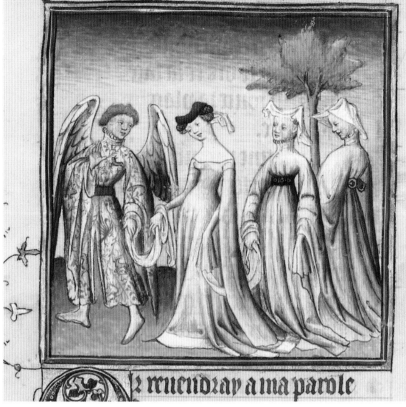

**33**

**The God of Love Dancing, fol. 8**

Once Idleness has admitted the narrator to the garden from which Avarice and the like are excluded, the latter sees a group of beautiful young people dancing. They include the God of Love (figure to the far left) in an outfit covered with depictions of lozenges, little shields, birds, lion cubs, leopards, other animals, and flowers; in other words, the writer was thinking of contemporary silk patterns (see fig. 1), though the original complexity of the design has here a relatively cursory treatment of animals and foliage. For the second figure, Beauty, the artist seems to have chosen the *cote hardie* to imply her simplicity and to have given it long sleeves to replace the heel-length blonde hair she has in the text. The third figure, Wealth, had an outfit of purple (a silk fabric, not necessarily in the color purple) of unmatched beauty, wealth, and style, which the artist has implied through her fur-edged *houppelande* with full sleeves and trailing under-sleeves. The Saracen "purple" outfit of the fourth figure, Generosity, gets a token reference in her purplish-red belt.

**34**

**The Personifications of Shame and
Anxiety Speaking to Resistance, fol. 95**
Shame is described as simple, honest,
and humble, and it therefore makes sense
that the illuminator has dressed her and
her cousin, Anxiety, in plain *cotes hardies*
and the tailed, open-fronted hoods of
non-aristocratic women. The text, however,
describes Shame as wearing a veil instead of
a wimple, like a nun in a convent. Resistance,
the male guardian of all the roses, is an ugly
peasant, while the courteous Fair Welcome
is presented as an exemplar of aristocratic
female fashion.

## 35

**Two Messengers from the God of Love Delivering a Letter to Venus, fol. 99v**

Venus (to the left with wings) was so stylish and so well turned out that she resembled a goddess or a fairy. Adonis (far left), described as a child, here wears a garment that presumably only youthful figures could wear. Probably called a *haincelin*, it has an egg-shaped torso and a center-front laced "skirt."

## 36

**Pygmalion, fol. 130**

Pygmalion was such an accomplished sculptor that he fell in love with his own masterpiece. The dagged garment hanging on a pole behind Pygmalion in this image stands for the multiplicity of garments with which he is about to begin dressing the statue. The text states: *Then he clothed her in many styles, in outfits made very skillfully from fine cloths of silk or wool, from scarlet, from* tiretaine [a fine woolen cloth], *from blue, from green, or from* brunette [black cloth], *in fresh, fine clean colors. Many had rich furs in them: ermine, miniver, gray* [squirrel]. *Then he would take them off and check how well an outfit of silk suited her* (ll. 20937–49). The silks included the lightweight silk called cendal, the shiny one called samite, and the one called *dyaspyn*, a white-on-white patterned silk (fig. 45 shows a surviving example).

DRESSING FOR THE MOMENT

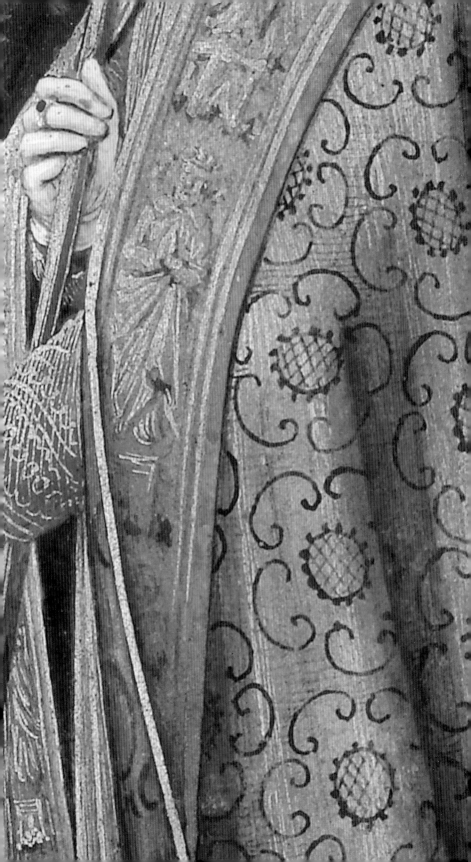

# DRESSING FOR THE JOB

*—And just how is that the gown of a marshal of France?*
*—Sire, I am a rough traveler; the gown matches the body.*
  *I had it made like this to come here by boat on the Seine.*

—King Henry V taking to task the marshal of France,
who had appeared before him in a garment of coarse white cloth.
Georges Chastellain, 1419–1422

## DRESSED TO RULE

C lothing was a vital part of making visible the social hierarchy, from royalty to the humblest peasant. Most of the time the ruling classes wore the most costly versions available of fashionable dress, but there were formal situations, such as coronations and other state occasions, when that was not dignified enough. Royalty and members of the nobility had to wear clothing that indicated their rank, not chiefly through monetary outlay, but, increasingly, through the use of specific outfits and articles of clothing that would never be worn at any other time. Many of these garments had once been fashionable, but they became items retained for occasions when currently fashionable dress might have seemed too ephemeral. Old-fashioned clothes perhaps suggested the good old days from which their wearers' status and authority had been inherited (see figs. 17, 40). They would be lined and trimmed with ermine (or cheaper furs imitating it), and specific motifs could identify the wearer and his rank, such as the fleur-de-lis for the king of France (fig. 41).

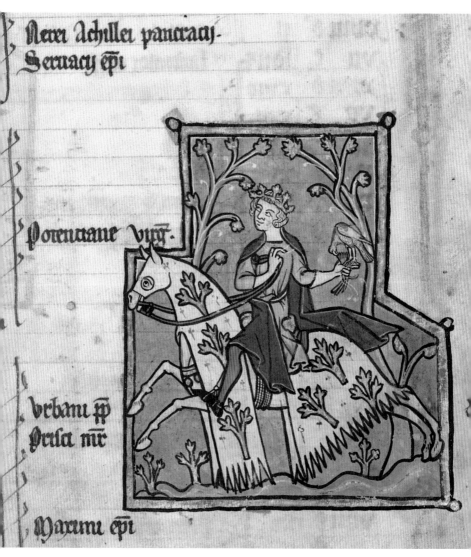

Neuer Achillei pancracij.
Seruacij ept

Potenciane ving.

vrbani ip
prfca mr

Maximi ept

**37**
**Calendar Scene for May:**
**A Man Hawking**
Psalter
Flanders, ca. 1250
JPGM, Ms. 14, fol. 5

Because his rank needs to be identifiable, this man, somewhat improbably, still wears his crown while out hawking. Contemporary fashion included a cloak that could prove dangerous because its cords had to be held at all times to prevent it from slipping backward and choking its wearer. The king or prince pictured here, however, seems quite accustomed to controlling his animals and possessions, as he effortlessly manages with the same hand not only his potentially deadly cloak but also his horse, while simultaneously feeding his hawk.

FASHION IN THE MIDDLE AGES

**38**
**King Mark of Cornwall Swears**
**to King Arthur to Forgive**
**Tristan**
*Romance of Tristan of Leonois*
Paris, ca. 1320–40
JPGM, Ms. Ludwig XV 5,
fol. 366

Clothes could even help in a thorny problem such as distinguishing between two kings in one scene. Both of the kings depicted here wear crowns, but the one on the left is otherwise attired as any man of standing might have been, with a hood and cape-sleeved overgarment. The king on the right is made more venerable by his beard and by his special overgarment, which bears three horizontal bars at the shoulders; he must therefore be Arthur, and the other man the less important Mark. (In real life such shoulder bars were part of the ceremonial wear of the sons of the kings of France.)

**39**
**Saint Hedwig of Silesia with Duke Ludwig of Legnica and Brieg and Duchess Agnes**
*Life of the Blessed Hedwig*
Silesia, 1353
JPGM, Ms. Ludwig XI 7, fol. 12v

Hedwig, a thirteenth-century saint, is shown with bare feet because her expressions of self-denying piety included walking barefoot in the snow. Her descendant, the duke Ludwig, kneels before her in reverence, expressing his rank by wearing brocaded fabric and ermine. The final mark of his standing is his braid-trimmed cap, an item frequently seen on male central European aristocrats. Meanwhile, his wife, the duchess Agnes, the small kneeling figure at right, with her headdress created from layers of veils with frilled edges and plain garments, could be any reasonably well-off central European woman.

**40**
**Saint Catherine Presenting a Kneeling Woman to the Virgin and Child**
Book of hours
Paris or Le Mans, ca. 1400–1410
JPGM, Ms. Ludwig IX 4, fol. 105

Along with her veil draped over a fashionable horn-shaped understructure, the aristocratic owner of this book of hours wears a *surcote ouverte* (compare to fig. 17) over a golden under-dress. The *surcote ouverte* had simply been a fashionable garment in the early part of the fourteenth century. Seventy years later, it is kept for only the most formal occasions, in this case a presentation to the Virgin and Child. Its skirt is decorated with a coats of arms (as yet not identified) declaring her family of origin on one side and the family she had married into on the other.

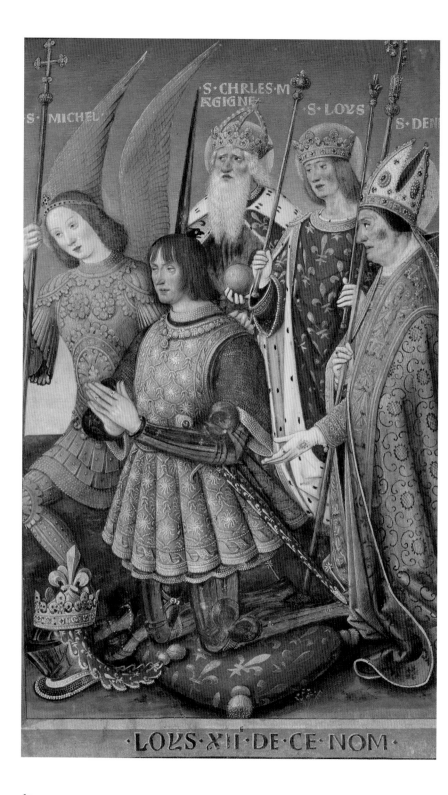

S · MICHEL

S · CHRLES · M
RGIGNE

S · LOYS

S · DENI

· LOYS · XII · DE CE NOM ·

FASHION IN THE MIDDLE AGES

At their coronations, the kings of France dressed in blue, ermine-lined garments covered in fleurs-de-lis; in this image these are worn by the second figure from the right, Saint Louis (r. 1226–70). The emperor Charlemagne (r. 800–814), to the left of Saint Louis, is traditionally shown with a long beard, a crown with a closed top, fleurs-de-lis, and the black imperial eagle of the Holy Roman Empire. Louis XII, kneeling in front, wears armor beneath an overgarment with fashionable tubular folds and decorated with his badge, a blazing sun. This is probably the same outfit as the one he donned for his first formal entry into Paris as king in July 1498, thereby demonstrating, as his predecessors had done, the king's right to rule by conquest.

This cope is made of Italian silk velvet with fine tracery-like patterns worked directly into the cloth as narrow areas of satin. Down the back of the cope run embroidered seraphim, fleurs-de-lis, and double-headed imperial eagles (fig. 41 demonstrates how a cope was worn). The original effect was probably much more striking as the velvet was possibly originally black, which tended to fade to brown—if the corrosive black dye did not simply eat through the threads first.

# SERVING GOD

At the top of the Church hierarchy stood the papacy, which included the pope and his cardinals (fig. 43). Administering the secular arm of the Church at the local level were archbishops and bishops, with various priests and other lower ranks of clergy (figs. 25, 44, 46). There were also monks and nuns, called the regular arm of the Church because they lived by the regulations of the various orders to which they belonged (figs. 47–50). The vestments worn by the celebrants of church services were made from valuable fabrics and, in addition, were often decorated with embroidered holy figures or scenes (figs. 8, 46; compare also figs. 41, 42). The clothing of monks and nuns, on the other hand, had to be made of cheap fabric as proof of their rejection of this world and its vanities. Although the Church was an ever-present power in daily life, artists (and their patrons) seem to have taken a fairly jaundiced view of many of the clerics they came into contact with, and to have enjoyed depictions of them suffering the torments of Hell (see fig. 51).

43
**Saint Jerome**
Master of the Getty Epistles
Getty Epistles
France, ca. 1520–30
JPGM, Ms. Ludwig I 15, fol. 1v

Saint Jerome (342–420) was an extremely influential early Christian scholar and writer, who also spent time as a hermit. He was usually shown in medieval images in one of two ways— as an unkempt, penitent hermit in the desert or as a doctor of the Church. In this image, which is a combination of the two, he appears sinewy and covered with sores, but his rich red robes and wide-brimmed flat hat, symbols of his role as cardinal, hang on the tree beside him.

FASHION IN THE MIDDLE AGES

**44**
**Initial *I*: A Martyr Saint**
Lippo Vanni
Cutting from an antiphonal
Siena, ca. 1350–75
JPGM, Ms. 53, recto

The saint wears a dalmatic, a vestment used during the Mass that was usually associated with deacons, members of the clergy who ranked below priests. The dalmatic's most obvious characteristics are the vertical slits at the sides, which are turned back here to reveal the blue lining.

**45**
**Dalmatic of Rodrigo Ximénez de Rada**
Spain, before 1247
Soria, Cistercian abbey of Santa María de Huerta

This dalmatic (see fig. 44) is made of the white self-patterned silk known as diasper or dyaspyn with contrasting bands woven in gold and silver threads. The vertical bands at the shoulders derive from similar bands that decorated ancient Roman tunics; but they and the bands at the chest, hem, and cuffs are made from fabric with inscriptions in Arabic, saying "blessing," "happiness," and "merciful." Such Christian-Muslim interchange was common in Spain.

**46**
**Office of the Dead**
Master of the Llangattock
Hours
Llangattock Hours
Bruges, ca. 1450–60
JPGM, Ms. Ludwig IX 7,
fol. 131v

A funeral service is conducted by two priests in black cloth-of-gold copes decorated at the shoulders with what look like images of the Annunciation to the Virgin Mary. In the stalls the rest of the clergy wear white surplices (linen over-tunics). Some of them also have almuces, on the shoulder, on the forearm, or on the head. The almuce was a long, hood-like garment made of fur, developed for the clergy of cold, northern European churches and worn by canons (who served in cathedrals and semiprivate collegiate churches) when they were, as here, in the choir.

**47**
**Initial C: Saint Benedict**
**Blessing Maurus**
Leaf from a breviary
Northeastern Italy, ca. 1420
JPGM, Ms. 24, leaf 4

Saint Benedict (ca. 480–547) was the founder of monasticism in western Europe. He and his student Maurus are shown here in the all-black Benedictine habit. Peter the Venerable, the abbot of Cluny, a reformed Benedictine abbey, wrote in the 1130s that black represented humility and repentance.

**48**
**Initial *M*: The Death of Saint Dominic**
Bolognese Illuminator of the First Style
Leaf from an antiphonal
Bologna, ca. 1265
JPGM, Ms. 62, recto

Saint Dominic, who died in 1221 in Bologna, founded the Order of Preachers, also known as the Dominicans. Although in later years their garments were a distinctive combination of a long, hooded black cloak over a white scapular (a narrow, poncho-like garment) and a white tunic, this scene shows that in the early days of the order, brown was as acceptable as black.

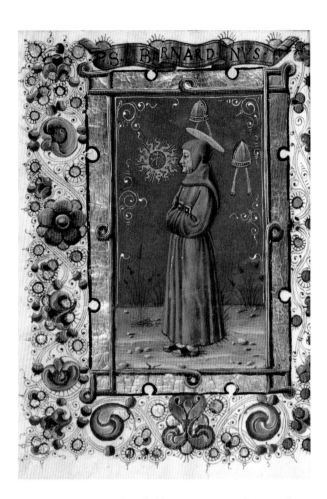

**49**
**Saint Bernardino of Siena**
Taddeo Crivelli
Gualenghi-d'Este Hours
Ferrara, ca. 1469
JPGM, Ms. Ludwig IX 13,
fol. 195v

The Franciscans were founded by Saint Francis of Assisi, who died in 1226. Saint Bernardino was a renowned Franciscan preacher who had attacked fashionable dress in many sermons before his death in 1444. Franciscans were required to wear undyed woolen habits, which were cheaper to produce than those with the strong blacks or clean whites increasingly adopted by other orders. Franciscans also wore the distinctive belt shown here, its three knots symbolizing the Franciscan vows of poverty, chastity, and obedience. Wearing sandals, or even going barefoot, was another feature of many orders that especially prized poverty and self-denial.

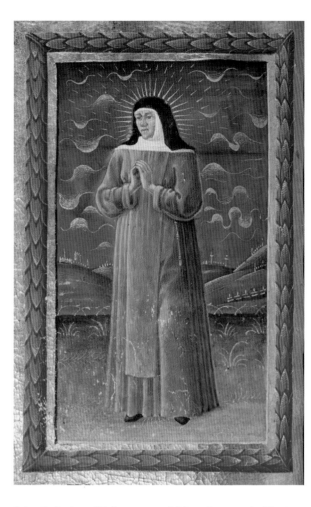

**50**
**Saint Catherine of Bologna**
Guglielmo Giraldi
Gualenghi-d'Este Hours
Ferrara, ca. 1469
JPGM, Ms. Ludwig IX 13,
fol. 185v

Saint Catherine of Bologna started life as Caterina dei Vegri, the daughter of an aristocrat from Bologna who served the marquis of Ferrara as a diplomat. As a girl she was an attendant and companion of the marquis's daughter, Margherita d'Este (sister of one of the owners of this book). When Margherita married, Caterina left the court at the age of fourteen to join the Franciscans, though Margherita wanted her to remain with her. Here Caterina is shown in her more famous role, as a highly revered Franciscan nun.

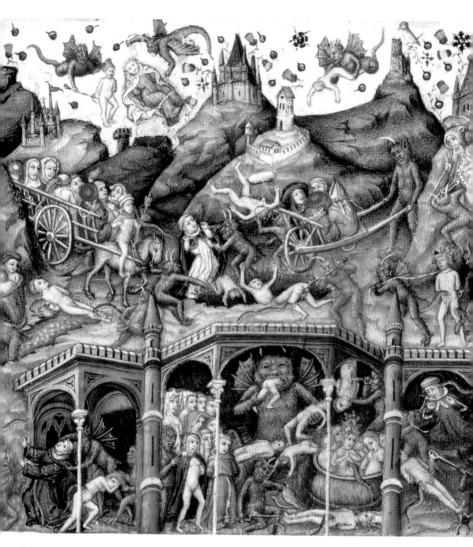

**51**
**Identifying the Damned
by Dress**
Master of the Brussels Initials
Book of hours
Paris, ca. 1400–1410
British Library, Add. Ms. 29433,
fol. 89

To make images of eternal torment in Hell more terrifying, art-
ists frequently demonstrated, by dress, that anyone could go to
Hell. Among the damned are, at the right, a king, naked except
for his crown, and an academic, wearing green, a color forbid-
den to academics and clerics alike. Even those who served
God could be condemned if their lives had not been free of
sin. Included are, in the cauldron a pope, naked except for his
triple crown; in a wheelbarrow, a bishop with his miter; nearby
a Dominican being grabbed at the edge of the fiery pit; and in
the portico, a nun, probably Benedictine, being stripped of her
clothing, next to a Franciscan friar in brown.

# ACADEMIC AWARDS

Men who sought high office in church or state generally needed a university education, in either church law or civil law; those who desired a career in medicine also had to study for years at a university. Writers were often shown as university graduates because their literary skills likewise placed them among the highly educated classes. In the thirteenth century the colleges that eventually formed the university in Paris began to specify what should be worn by their teachers, their students, and those of their graduates whose careers would depend upon their academic qualifications. This was done in an effort to stamp out the lack of dignity that fashionable dressing would bring to their representatives. Their clothing had to be full length, and fashionable colors had to be avoided. By the fifteenth century it could be identified quite easily because it retained fourteenth-century forms. Scarlet was the fabric most commonly used to denote the achievement of high standing, that of a doctor of any university subject. Such clothing made their wearers instantly identifiable, whether in life or in art.

52
**The Struggle between Fortune and Poverty Witnessed by Boccaccio**
Boucicaut Master
Giovanni Boccaccio,
*Concerning the Fates of Illustrious Men and Women*
Paris, ca. 1415
JPGM, Ms. 63, fol. 63

The fourteenth-century Italian writer Giovanni Boccaccio, the author of this text, is shown by the later French illuminator of this manuscript in the clothing of a member of the University of Paris, with a red hood and a crimson-pink *houce* (a long overgarment with wide, cape-like sleeves and white tabs on the chest). Shades of red were common in the dress of holders of the degree of doctor; and the status that red conferred is reinforced by the use of red clothing for the crowned figure of Fortune.

L e premier chapitre du tiers liure
contient le debat de pauurette et de for
tune commencant oulatin. Con
cucuere et c.

Gleins et aul
tres voyageurs
qui font aulain
longr et labou
rieur chemin.
ont de coustume
eulx arester.
Galune des:

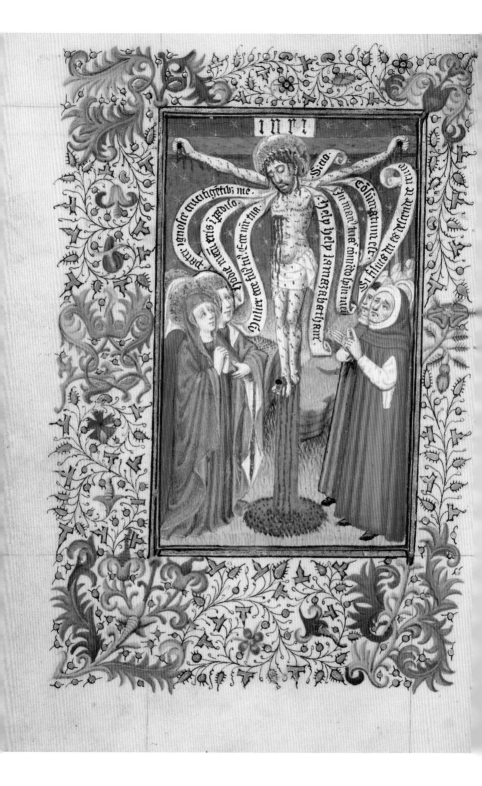

**53**
**The Crucifixion**
Fastolf Master
Book of hours
Probably Rouen or England (?),
ca. 1430–40
JPGM, Ms. 5, fol. 16v

The scroll of the man on the extreme right reflects the words attributed to the chief priests, the scribes, and the elders in the Bible: "If you are the Son of God, come down from the cross." The full-length, shapeless gowns with old-fashioned hoods, worn with the fur lining framing the face, that are common in depictions of French lawyers, appear here on the men on the right because Jewish scribes were understood in the fifteenth century to be the equivalent of scholars of the law.

---

**54**
**Saints Cosmas and Damian**
Workshop of the Bedford
Master
Book of hours
Paris, ca. 1440–50
JPGM, Ms. Ludwig IX 6,
fol. 218

Saints Cosmas and Damian were early Christian martyrs whose legend says that they were twins and also both medical doctors. They are frequently shown in physicians' robes; in Paris, where this image was created, those who taught medicine at the university were required from 1350 onward to wear good-quality, violet-colored cloth. The patterned edging on their cape-sleeved garments (*houces*) here is part of the illuminator's desire to make the saints' clothing more special, but it was not part of the actual dress of doctors.

C lothing for those involved in manual labor tended to be shorter than the clothes of the more leisured or professional classes, but even then it might be worn tucked up (compare the master mason with his set square and the workmen in fig. 55). Realistically, the working classes were also less likely to be able to own highly fashionable or colorful dress and would certainly not wear it for work, although illuminators sometimes added colorful elements for visual effect (compare figs. 3 and 64). Servants in great households could be identified by the colors they wore, sometimes in *mi parti* (clothing split vertically into halves of two different colors), which initially identified their rank within a household; but by the fifteenth century *mi parti* had come to identify them as servants of a particular household (fig. 58). Servants who worked close to great lords were usually given fashionably cut clothing that might include varying degrees of *mi parti*.

55
**Initial *I*: The Rebuilding of the Temple**
Marquette Bible
Lille, ca. 1270
JPGM, Ms. Ludwig I 8,
vol. 3, fol. 256v

et eaque ipsi intelligimus in
nra lingua pmere. Itacz licet
excetra sibilet. uictozcz synon
mcendia iactet: nunquam meu
nuuante xpo silebit eloquium
etiam precisa lingua balbuti
et. Legant qui uolunt: qui no
lunt abiciant. Cuentulent api
ces. litteras calumpnient. Ma
gis ura caritate puocabor ad
studium: quam illozum detra
ctione & odio deterrebor. Expli
cit pfacio. Incip lib ezre. Caplm

IN anno primo cyri regis
pfarum ut impletetur uerbu
dni ex oze iheremie susritauit
dns spm cyri regis pfarum: et
transduxit uocem in uniuso
regno suo. etiam p scripturam
dicens. Hec dicit cyrus rex pfar.
Omnia regna terre dedit mi
chi dns ds celi: et ipse pcepit in
ut edificarem ei domum i ierlm

**56**
**Initial *V*: Nehemiah
Serving King Artaxerxes
with Wine**
Marquette Bible
Lille, ca. 1270
JPGM, Ms. Ludwig I 8,
vol. 3, fol. 265

The Old Testament Persian king Artaxerxes is dressed like
a thirteenth-century French king, while his Hebrew servant
Nehemiah, in his *mi parti* outfit, resembles a young servant
in a thirteenth-century aristocratic household.

vuj f jɔ⁹ la tiↄiphane
g jɔ⁹ Saint frambour
rbi jɔ⁹ Saint lucien.
v b jɔ⁹ Saint pol.
c jɔ⁹ Saint guille.
rui d jɔ⁹ Saint laurieur.
ii e jɔ⁹ Saint latu.
f jɔ⁹ Saint hylaur.
r g jɔ⁹ Saint felir.
jɔ⁹ Saint mozз bon

**57**
**Calendar Scene for January:**
**Feasting**
Workshop of the Bedford
Master
Book of hours
Paris, ca. 1440–50
JPGM, Ms. Ludwig IX 6, fol. 1

Employing handsomely dressed servants reflected well on a
household, as illustrated here. These servants in their fashion-
able outfits betray their lesser position in life solely by the
towels they have slung over their shoulders, ready to mop up
any spills.

58
**Meal before the Hunt**
Gaston Phébus, *Book of the Hunt*
Brittany, ca. 1430–40
JPGM, Ms. 27, fol. 60v

The three liveried servants in *mi parti* wear fashionable clothing identical in cut to that of their employer, the man at the table with the dark rolled hood on his head.

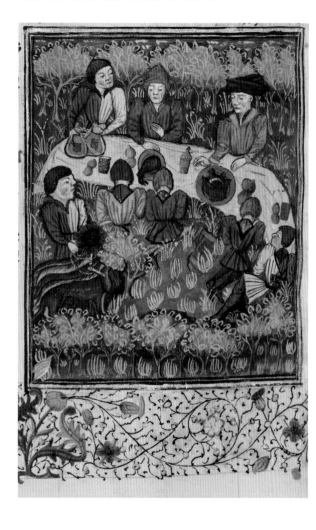

59
**Camouflaged Hunters Preparing to Attack a Deer**
Gaston Phébus, *Book of the Hunt*
Brittany, ca. 1430–40
JPGM, Ms. 27, fol. 109

Camouflage was deemed an essential tool for sneaking up on prey; here, in accordance with the text's instructions, two men in green, with greenery on their heads, ride their horses in single file, while two archers wait in the trees. The archers, in order to be able to move more freely, have stripped down to their doublets (under-jackets), whose puffed upper sleeves show how the wide-shouldered look of fashionable men's clothing was achieved.

qui touctrut alatenene se pr
tr que icu say et pour dirap
comment atrauir des ares ou
preut les bestes sauz thacer
aurcpicus cest mettre les des

fermit tenir et tuider par uys les
aupiers. Cőme on doit mettu
les bestes au tour pour traere.

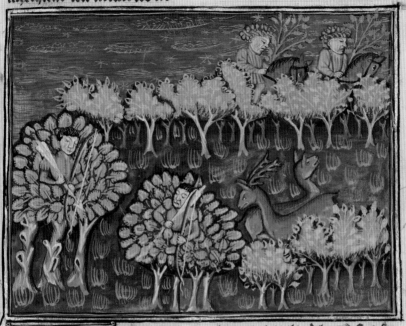

unt en au
tr manie
re a mettr
autour
qui se fait
eu telle manier ou doit auoir
deux cruaux achiin cheual
aut on homme desus sestu des

rent et chapelet de bois desus sa
teste pour mieulr couurir sa teste
et son visaige et doit aler lun che
ual apres lautre le plus pres qil
pourra le uuisel sus la queue de
lautre. Et quant on uerra
les bestes au matin ou au bespre
a la leuee ou en yuer la ou elles

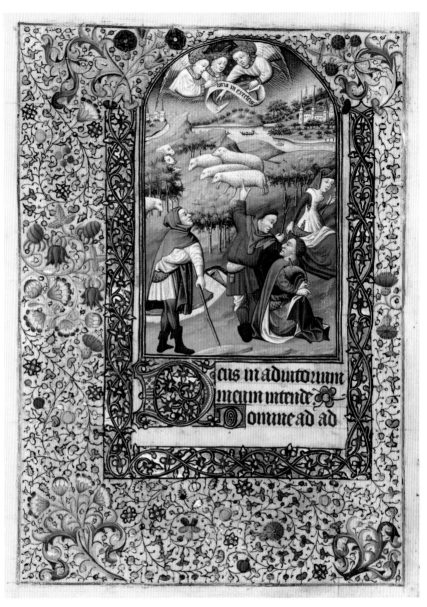

**60**
**The Annunciation to the Shepherds**
Workshop of the Bedford Master
Book of hours
Paris, ca. 1440–50
JPGM, Ms Ludwig IX 6, fol. 73v

Shepherds are usually depicted in clothing in which fashion plays little or no part. Only shepherdesses, such as the woman here on the right, are shown as having any awareness that such a thing as fashion exists. This shepherdess has protected her tight-fitting *cote hardie* under a side-laced overall. Shepherds, as here, carried their possessions in nets or loose bags slung around their hips.

FASHION IN THE MIDDLE AGES

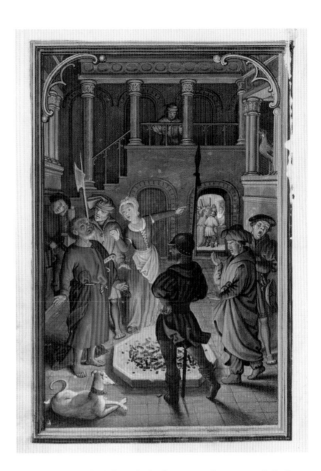

**61**
**The Denial of Saint Peter**
Simon Bening
Prayer Book of Cardinal
Albrecht of Brandenburg
Bruges, ca. 1525–30
JPGM, Ms. Ludwig IX 19,
fol. 123v

Saint Peter, on the left, is clothed in a simple tunic and cloak, one version of the dress employed for biblical figures (compare his appearance more than five hundred years earlier in fig. 68); he is pointed out as a follower of Christ by the high priest's maidservant. Her underdress is the same type that women had been wearing for at least a hundred years, with a laced bodice and short sleeves to which false, contrasting sleeves have been attached. On top of this she wears an apron, tucked up to one side. Her headdress, based on that of lower- and middle-class Flemish women, is composed of a rectangular piece of linen starched into a dip over the forehead, and here tied up out of her way, over the back of her head (see also fig. 64). The men in the green gowns have been given, on the left, a gray, fifteenth-century hood, and on the right, a sort of turban, to help lend a "historical" air to the scene; but the sleepy servants in dark ocher garments wear clothing fashionable at the time of the manuscript's creation.

Prayer books known as books of hours always begin with a calendar that lists saints' feast days and holy days of the Church, month by month. The calendars include scenes that show the major worldly activities for each month, primarily concerning peasants working with animals and tending to crops. However, in the warmer months of the year aristocrats can also be found enjoying themselves outdoors. The images that accompany the calendars in books of hours are our best source for understanding how the seasons of the year and the activities appropriate to them affected dress.

Spinola Hours (calendar section)
Workshop of the Master of James IV of Scotland
Bruges and Ghent, ca. 1510–20
JPGM, Ms. Ludwig IX 18

**62**

**Calendar Scene for January: Feasting and Keeping Warm, fol. 1v**

Keeping warm was a major theme of calendar scenes for January, and clearly, it was a difficult task. The man sitting nearly in the fireplace still wears a hood and hat indoors; outside, a man wears a cloak and a muffler, while his hands have been plunged into his sleeves. Feasting was another common subject for January, with the woman at the table setting out a meal. Either she was kept so warm by cooking that she could dispense with her outer layers or, as her apron implies, she had to protect her more formal outer layers from cooking stains and splatters and has removed them, despite the cold.

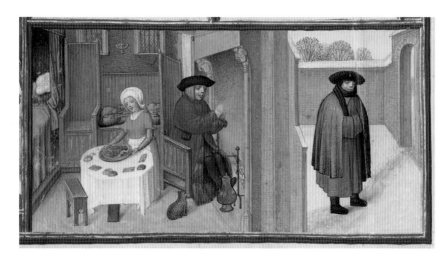

**63**

**Calendar Scene for March: Gardening, fol. 2v**

In March the owner of the moated castle in the background watches his gardeners at work. The warmer weather allows him to wear a shorter gown, but it is still fur lined and held closed over the chest. The black silk French hood of the woman beside him identifies her as a lady, as does her wide-sleeved, square-necked French gown. The neckline is partly filled in by a black under-collar that helps to protect her against both the sun and any sudden chilly wind. Little can be said about what the gardeners wear except that it can be called clothing.

**64**

**Calendar Scene for April: Farm Animals, Milking, and Buttermaking, fol. 3**

The clothing of the female farm workers seems to be of undyed wool, which can achieve a surprising variety of shades from very dark brown to white, depending on the proportions in which the fibers are mixed. Like the headdress of the servant in figure 61, that of the woman milking the cow has been knotted up at the back of her head. The shepherds wear remarkably bright colors, and one even has gold edging on his gown; these features must be regarded as artistic embellishments for the benefit of the book's owner, who might otherwise have found the scene too colorless.

**65**

**Calendar Scene for May: Music-Making, fol. 3v**

Bringing the first greenery into the city from the countryside was a favorite theme for May, and it could be combined with boating and riding parties, as here. An aristocratic party glides along, making music, in the company of a jester in a cap with "ears." The woman wears a man's cap on top of her French hood, probably as extra protection against the growing power of the sun. The gold highlights on some of the clothing may be meant to suggest the sheen of silk in sunshine.

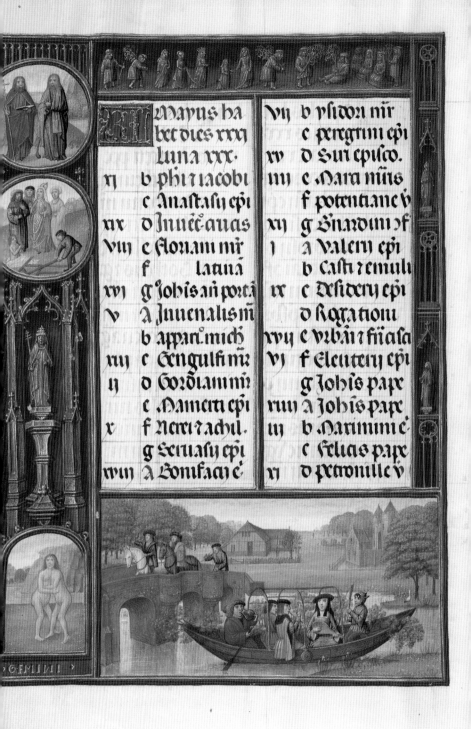

| | | | |
|---|---|---|---|
| | Mayus habet dies rrri luna rrr· | Vij | b psidon mr |
| rj | b phi z iacobi | | c peregrini epi |
| | c Anastasij epi | rv | d Suj episco. |
| rir | d Innec auas | iiij | e Mara mus |
| Vij | e floram mr | | f potentiane v |
| | f latina | rvj | g Bnardm of |
| rvj | g Iohis an porta | j | a valerij epi |
| v | a Iuuenalis m | | b casti z emuli |
| | b apparl.mich | ir | c Desidery epi |
| riiij | c Gengulfi mr | | d Rogatiom |
| ij | d Gordiam mr | rvj | e vrban z fri asa |
| | e Mamerti epi | vj | f Eleuterij epi |
| x | f Nerei z achil. | | g Iohis pape |
| | g Seruasij epi | riiij | a Iohis pape |
| rvij | a Bonifacij e | iij | b Maximini e |
| | | | c felias pape |
| | | rj | d petronille v |

DRESSING FOR THE JOB

89

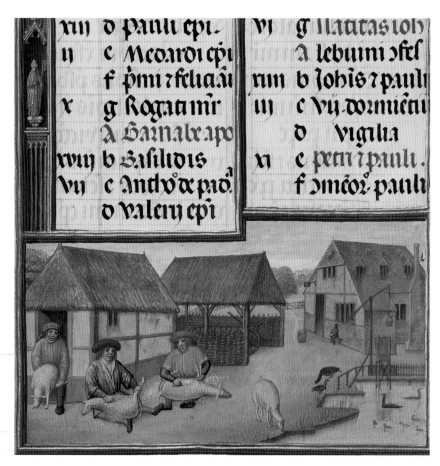

col. pauli epi.
ii c Meoardi epi
f pmi z feliau
x g Rogati mr
a Barnabr apo
xvii b Bafilidis
vii c Antho ac pao
o valeni epi

vi g llatitas ioh
a lebuini ofct
xiii b Johis z pauli
iii c vii domieti
o vigilia
xi c petri z pauli
f ameoz pauli

**66**

**Calendar Scene for June: Sheep-Shearing, fol. 4**

Once again, improbably colorfully dressed shepherds appear (see fig. 64), this time shearing their sheep in preparation for the heat of the summer.

**67**

**Calendar Scene for July: Mowing, fol. 4v**

Working in the fields in the heat has caused one of the men to strip down to the bodice of his doublet and his tights, whose seams have been carefully depicted. Broad-brimmed hats are worn as shields against the sun's rays. Since sun-tanned skin indicated that one worked outdoors, the women have tried to find a compromise between protecting their skin and not being too hot—they have removed their false sleeves and left their undershirt sleeves exposed. As we see here, peasant women could not work and wear the trailing skirts of high fashion.

OUTFITTING FOR THE SEASONS

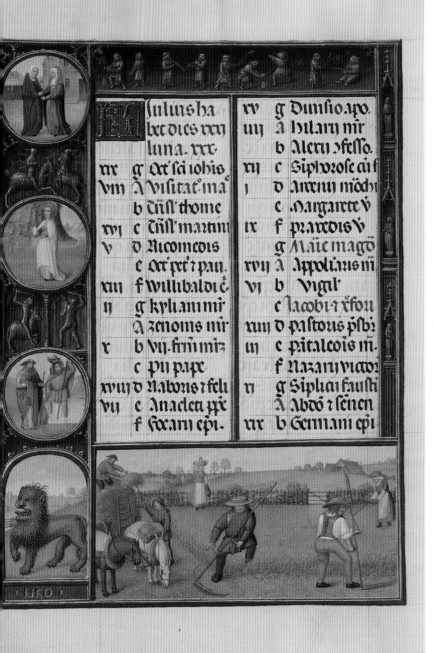

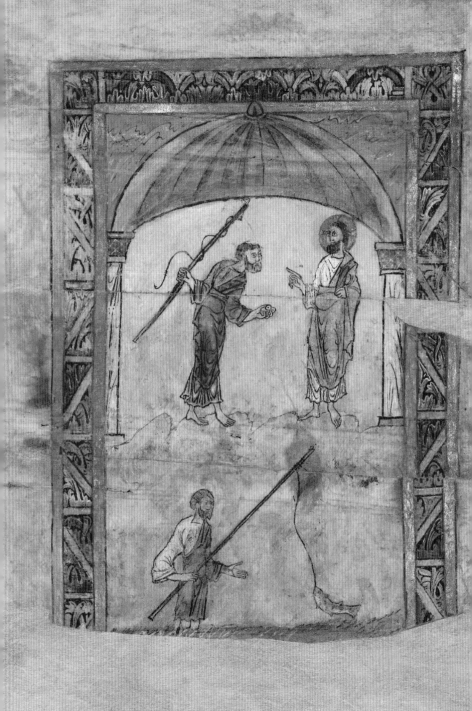

# DRESSING FOR ANOTHER TIME, ANOTHER PLACE

*And to follow the antique style . . . the statue [of the Roman poet Virgil] should be on its own with a laurel wreath on its head, and with an antique-style cloak, as in the toga outfit, gathered up on the shoulder, or with the senatorial outfit, that is the tunic and cloak above it . . . with antique-style shoes.*
—Jacopo d'Atri to Isabella d'Este, on her proposal to erect a statue to Virgil, 1499

## BIBLICAL TIMES AND THE HOLY LAND

The religious nature of many illuminated manuscripts meant that artists were trying to make visible for their patrons people and events from the past. Certain conventions gradually arose for dressing biblical or historical characters, based on, at first, the dress seen in surviving late-Roman manuscripts (for Christ and the apostles), and, later on, fanciful versions of the dress worn in the Middle East and beyond. Nearly anyone—apart from God, Christ, the Virgin Mary, and the apostles—could be depicted wearing this fanciful clothing. The dress of angels (see the borders in fig. 71) derived from that worn by junior members of the clergy when the church performed religious dramas; some of the fanciful clothing was used in theatrical entertainments.

**68**
**The Miracle of the *Stater***
Leaf from a Gospel book
England, probably
Canterbury (?), ca. 1000
JPGM, Ms. 9, leaf 2

Saint Peter finds inside a fish a coin (*stater*) with which to pay taxes. Both he and Christ wear standard "biblical" dress, a T-shaped tunic beneath a rectangular cloak wrapped around the body and slung over the left shoulder. They are both barefoot, another convention used for biblical figures (see also figs. 69 and 70).

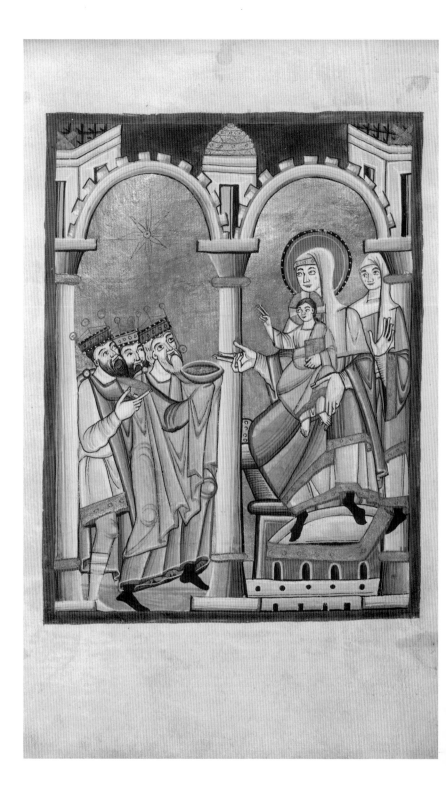

FASHION IN THE MIDDLE AGES

**69**
**The Adoration of the Magi**
Benedictional
Regensburg, ca. 1030–40
JPGM, Ms. Ludwig VII 1,
fol. 25v

The Magi, the Virgin, and her attendant all wear contemporary dress; the infant Christ is clothed in the standard T-shaped tunic and diagonally wrapped cloak associated with biblical dress.

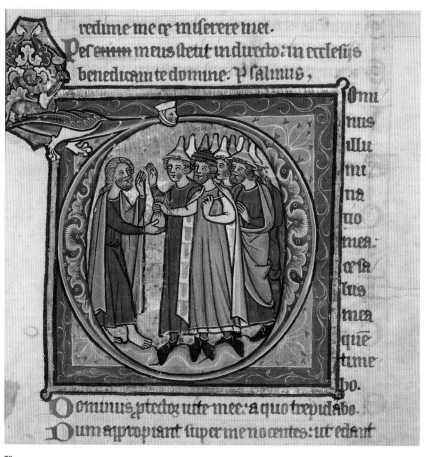

**70**
**Initial *D*: Judas Receiving the Thirty Pieces of Silver**
Psalter
Flanders, ca. 1250
JPGM, Ms. 14, fol. 39

The words of Psalm 27, "Do not deliver me over to the desire of my adversaries: for false witnesses have risen up against me," may have inspired the illuminator to produce here what is basically an image of Judas Iscariot accepting a bag containing thirty pieces of silver from the priests to betray Christ. The man taking the money is barefoot, as are many biblical figures (see also figs. 68 and 69); most of the other men wear the pointed hats often used to denote Jewish figures at this date. Their leader is differentiated by his flatter hat, his miniver-lined cloak, and his fashionable gesture in hooking his fingers over its cord (see fig. 37).

**71**
**The Way to Calvary**
Spitz Master
Spitz Hours
Paris, ca. 1420
JPGM, Ms. 57, fol. 31

In the early fifteenth century it was common to decorate dress in biblical or historical scenes with gold bands, sometimes in versions of Arabic script, and sometimes, as here, with parallel lines enclosing circles. These designs apparently came originally to western Europe in textiles imported from the Middle East, where the Arabs held sway, as genuine relics from the time of Christ. The soldiers' outfits are an early attempt to depict ancient Roman armor, which featured protective strips that hung from the waist.

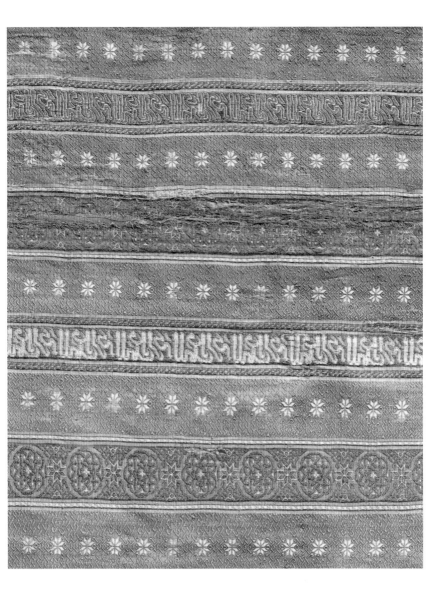

**72**
**Silk from the Tomb of Berenguela, Queen of León and Castile**
Andalusia, ca. 1246
Burgos, Monastery of Santa María la Real de Huelgas
Patrimonio Nacional, inv. 00650513

Berenguela was queen of León and Castile and the daughter of Enrique I (owner of the *pellote* in fig. 15). This silk is decorated in the bands associated in western Christian minds with Arabic textiles and indeed has Arabic inscriptions and circles that Christian artists came to use in exotic or Biblical figures' dress (see fig. 71). The gold thread used here is 88% pure gold.

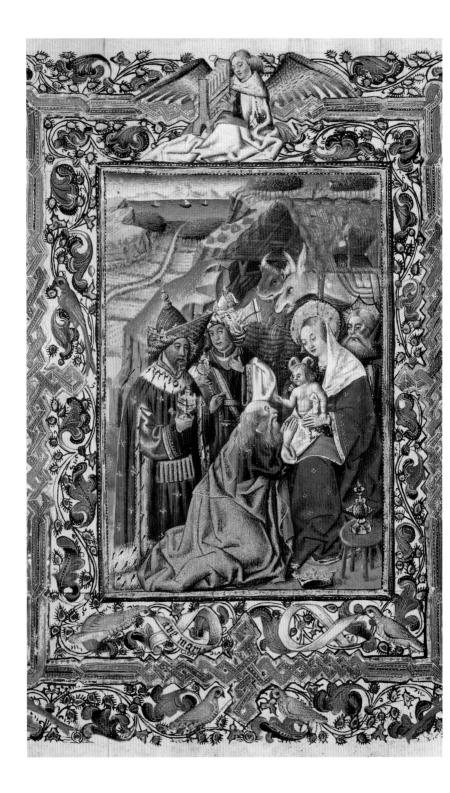

FASHION IN THE MIDDLE AGES

**The Adoration of the Magi**
Book of hours
Naples, ca. 1460
JPGM, Ms. Ludwig IX 12,
fol. 256v

In this south Italian manuscript the balding, oldest Magus, in his simple tunic and cloak, wears "biblical" dress, while his two companions seem much more theatrical. The middle-aged Magus (in the ermine-lined garment) has a hat that must have been inspired by widely disseminated images of the Byzantine emperor, who visited Italy in the late 1430s. The youngest Magus wears a sort of turban made of striped fabric. Striped fabrics were associated with Middle Eastern dress in the European mind during this era, with some justification.

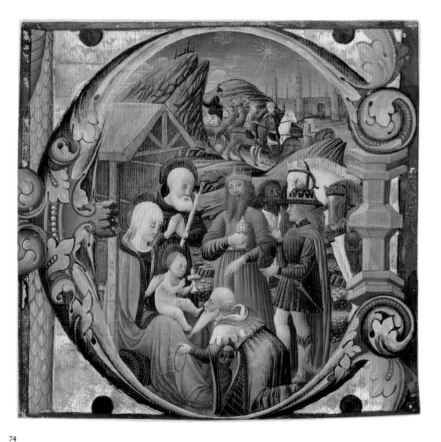

74
**Initial *E*: The Adoration of the Magi**
Franco dei Russi
Cutting from a choir book
The Veneto, 1470s
JPGM, Ms. 83, recto

A few years later, and much farther north in Italy, the eldest Magus is shown kneeling before the Holy Family in a garment with hanging sleeves that recall those of the mid-fourteenth century, and a hood with slashing that could come from the fourteenth or early fifteenth century. The youngest Magus has the short gown of contemporary Italian dress, multicolored stockings (also part of contemporary fashion), and an exotic hat.

FASHION IN THE MIDDLE AGES

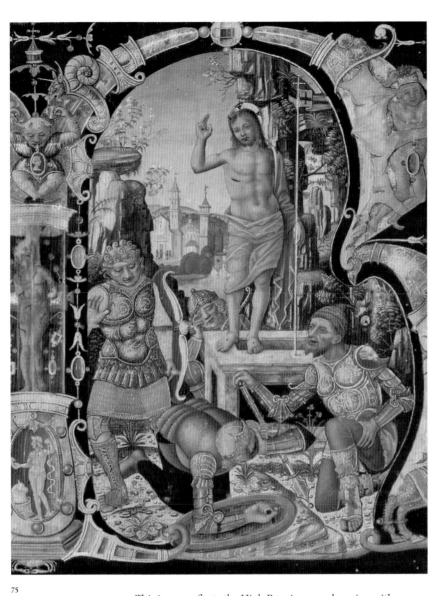

75
**Initial *R*: The Resurrection**
Antonio da Monza
Gradual
Rome, late 1400s or early 1500s
JPGM, Ms. Ludwig VI 3, fol. 16

This image reflects the High Renaissance obsession with re-creating Classical antiquity as accurately as possible. The soldier on the left wears a much more sophisticated version of Roman armor than that pictured in figure 71. The risen Christ is almost a Classical nude, with only his rectangular cloak being retained from his traditional dress. Even the jewels that decorate the frame of the scene include, as contemporary jewelry did, real or fake cameos imitating those made in ancient Rome.

**76**
**Initial *A*: King David**
Matteo da Milano
Missal
Rome, ca. 1520
JPGM, Ms. 87, fol. 52v

King David has been given conventional elements denoting his Middle Eastern origin—a turban, fake script on the edges of his cloak—and one element that must derive from accurate knowledge of contemporary Middle Eastern dress, clasp-like fastenings on his gown.

This Bible, made for Armenian Christians in Persia, features the Old Testament Jewish king David decked out in the bejeweled ceremonial dress of the Christian Byzantine emperors who had ruled the eastern portion of the Roman Empire. Although the Byzantine Empire had fallen to the Ottoman Turks in 1453, Byzantine artistic traditions survived. There is some logic in reviving Byzantine imperial dress (compare to fig. 78) for a manuscript made for Christians in a Muslim country, since the emperors had traditionally taken under their protection Christians living under Muslim rule in the Middle East.

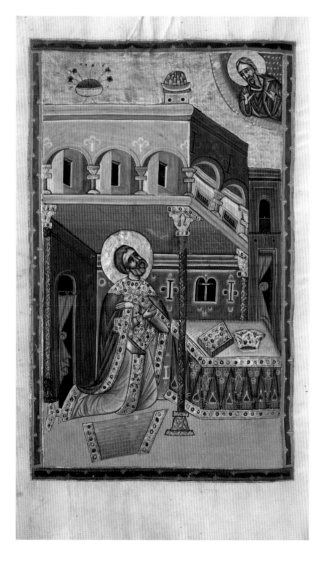

# ANCIENT GREECE AND ROME

nother part of history that particularly appealed to medieval western Europe told of the ancient world with its great military heroes, Alexander the Great of Greece and Julius Caesar of Rome. When illuminators painted scenes from the ancient world, they fell back, mainly, on the exotic clothing used for biblical scenes. In this section, we have a chance to look at some alternative ideas as well.

78
**Alexander the Great Welcomes the Queen of the Amazons and Her Followers**
*Book of Ancient Histories*
Acre, ca. 1286
British Library, Add. Ms. 15268, fol. 203

Alexander the Great was a Greek king; the Byzantine emperor in Constantinople would have been the Greek ruler best known to the Crusaders who owned this book in the thirteenth century. Alexander, therefore, is shown as a Byzantine ruler, wrapped in the narrow gold band called the *loros* that was a central part of the Byzantine regalia, and a crown with pendants (compare to fig. 77). Pearls were used, as here, to decorate the shoes of the Byzantine emperor (see also the glove in fig. 79, made in Sicily where Byzantine influence was strong). The queen of the Amazons is similarly seen in Byzantine terms.

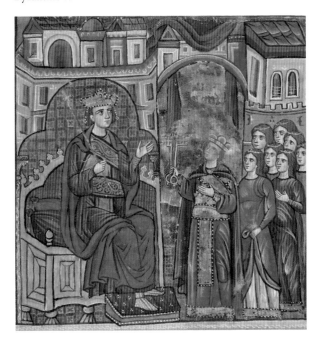

**79**
**Glove**
Palermo, ca. 1220
Vienna, Kunsthistorisches
Museum, Weltliche
Schatzkammer, Inv.-Nr. XIII 11

This glove, probably made for Frederick II to wear at his coronation as Holy Roman Emperor in 1220, is made of red samite (a slightly shiny silk fabric) and is encrusted with gold embroidery, pearls, precious stones, and small enameled plaques. Palermo, the capital of the multicultural island of Sicily, was famous for the silks made in its royal workshops and for the way in which its sumptuous fabrics were further enriched by the addition of jewels. The trimming of the cuff of the glove with pearls echoes the trimming of the Byzantine-inspired dress of the Amazon queen in figure 78; pearls adorned the shoes of Byzantine emperors, as they do those of Alexander the Great, also in figure 78.

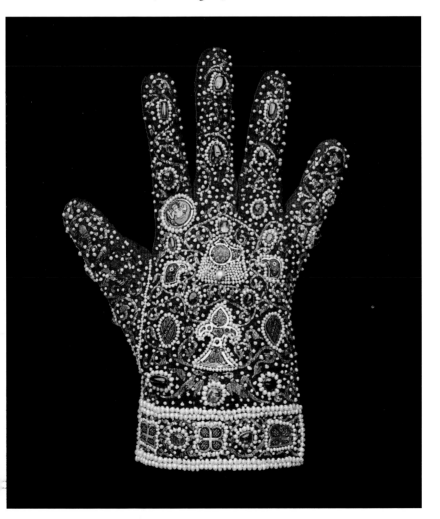

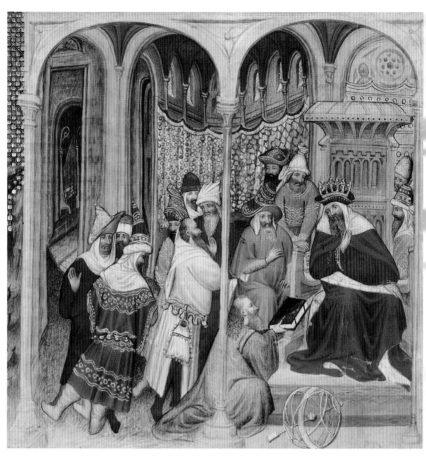

**80**
**Alchandreus Presenting His Book to Alexander the Great (?)**
Virgil Master
Alchandreus, *Book of the Philosopher Alchandreus*
Paris, ca. 1405
JPGM, Ms. 72, fol. 2

**81**
**Julius Caesar Receiving the Homage of the Gallic Ambassadors**
Godefroy le Batave
François du Moulin and Albert Pigghe, *Commentaries from the Gallic War*
Paris or Blois, 1519
British Library, Harley Ms. 6205, fol. 43

Alexander, who was clean-shaven and died at age 32 in 323 B.C., is possibly shown here as an elderly gray-bearded ruler wearing a miniver-lined cloak and a crown over his hat. Once again, decorative gold bands have been applied to much of the clothing, and oddly shaped hats have been added to the turbans. Exotic figures are often also depicted as rather pot-bellied, in contrast to the slender figures of purely contemporary men.

The seated Julius Caesar is to be understood as wearing Roman military attire (but with the addition of early sixteenth-century two-part sleeves). The Gallic ambassadors, ancestors of the French, are dressed in an approximation of French styles of about 1470, but the artist has either failed to realize, or has chosen to forget, that in the fifteenth century puffed upper sleeves belonged on doublets, not gowns (compare to figs. 25 and 59).

FASHION IN THE MIDDLE AGES

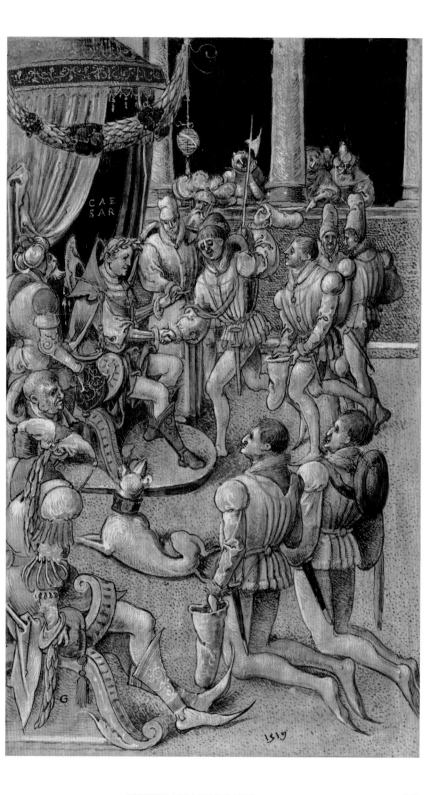

**82**
**Philosophy Consoling Boethius**
Coëtivy Master
Boethius, *On the Consolation
of Philosophy*
Paris, ca. 1460–70
JPGM, Ms. 42, leaf 1v

The philosopher Boethius (executed A.D. 524) is visited in
prison by Philosophy. His gown is not fashionable, but its
length and its color recall academic dress (compare to fig. 52).
Philosophy's outfit is entirely fashionable, except for her nar-
row belt and the application of pearls or beads at her wrists
and her hem. The artist has chosen the tallest type of contem-
porary headdress, in accordance with Boethius's description of
her as seeming to touch the sky (in this case, the canopy).

**83**
**Philosophy Presenting
the Seven Liberal Arts
to Boethius**
Coëtivy Master
Boethius, *On the Consolation
of Philosophy*
Paris, ca. 1460–70
JPGM, Ms. 42, leaf 2v

Philosophy refers to Boethius's education in academic mat-
ters, which in the Middle Ages meant the Seven Liberal Arts.
Each discipline is represented here by a female personification.
They are led by Grammar in a low-set and rather old-fashioned
thick linen veil and a cloak; almost as unassuming is Rhetoric,
behind her, with a scroll. Next to Rhetoric stands Logic (hold-
ing a sieve to strain out points in arguments) with a version of
the fashionable "steeple" that also forms the basis of the head-
dresses of Philosophy (beside Boethius) and Astronomy (on
the extreme right). Geometry's derives from the same model,
although hers is covered with a padded blue roll drawn up into
"horns," a less usual but still fashionable style. Headdresses
with a more exotic air are worn by Arithmetic (beside
Geometry) and Music, who wears a status-laden blue and gold
*surcote ouverte* lined with ermine. The *surcote ouverte* is also
the basis for the overgarment of Astronomy (far right), which
is made unconventional by the folds at the front neckline and
by the squared-off lower edges of its "armholes."

A lexander the Great (356–323 B.C.) was a favorite hero of the Burgundian court and especially of the Duke of Burgundy, Charles the Bold (r. 1467–77). The translation into French by Vasco da Lucena of what was left of Quintus Curtius Rufus's Latin biography of Alexander the Great was completed, with additions to fill in the gaps, in 1468 and was dedicated to Charles (fig. 84). Fashionable elements in the dress show that this particular manuscript was made soon afterward. Turbans and short over-sleeves are the most common indicators that the scenes are not actually contemporary. If there is any attempt to depict Alexander changing from Greek to Persian clothing, as happened in 330 B.C. when he wanted to encourage the integration of his Greek and Persian subjects, then it is presumably to be found in the switch from a patterned gold gown with a pleated waist in contemporary Burgundian style (fig. 86) to a loose, usually all-gold, gown with short sleeves (fig. 87).

---

*Book of the Deeds of Alexander the Great* by Quintus Curtius Rufus
Master of the *Jardin de Vertueuse Consolation*
Lille and Bruges, ca. 1468–75
JPGM, Ms. Ludwig XV 8

**84**
**Vasco da Lucena Giving His Work to Charles the Bold, fol. 2v**
Charles the Bold, seated, wears the collar of the Burgundian chivalric Order of the Golden Fleece with one of the (apparently) entirely gold gowns he is often shown wearing in illuminations;

here this fabric links him to Alexander the Great (fig. 87). His courtiers wear either full-length or very short gowns with over-long slit sleeves, some have extremely nipped-in waists. The nobles also wear fashionably long hair and tall hats.

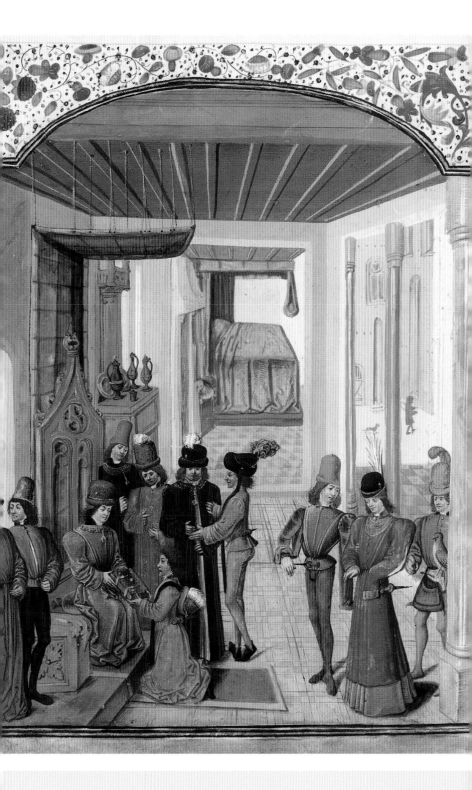

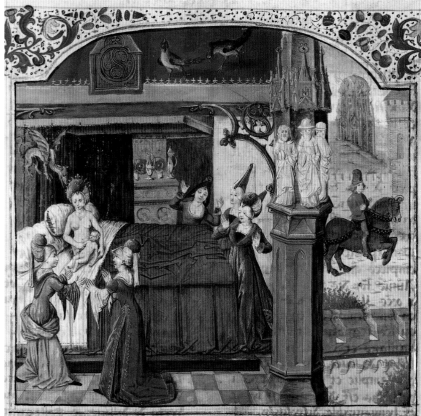

Cr commence le premier liure assamble de plusieurs et adiouste au
histoires de quintecurse Ruffe lequel contient .xxxiij. chapitres
Dont le premier parle comment ce histoires dalexandre puelt ap
paroir que les toraulmes croissent p vertu de dilligence et dedment

**85**

**The Birth of Alexander the Great, fol. 15**

As modern viewers raised in the age of
cinema and television, we may expect
narrative consistency in works of art. But
confusingly, in this manuscript turban-
like headdresses were not reserved solely
for people whom Alexander encounters
in the Middle East but are also worn by
Alexander's mother and her court ladies
in Greece. In fact, they wear the most
elaborate turbans in the entire manuscript!
Contemporary elements include the fine

veils covering the foreheads of the women
(such veils were worn with contemporary
"steeple" headdresses), and the V-necked
fur collars (see also fig. 23). The short
over-sleeves and wide under-sleeves,
however, and the long side slit on the blue
gown take us straight back to the exotic.
By contrast with the later images of him
in the manuscript, the young Alexander
on horseback at the right is a perfect
Burgundian youth.

Cy commence le quart liure de Quintecurse lequel contient en son
xxbin. chapitres. Le premier desquels parle du conseil que le roy-

**86**

**The Competition in Sittacene and
the Placating of Sisigambis, fol. 99**

On the left, Alexander's men look almost
exactly like Burgundian courtiers as
they take part in athletic competitions.
However, two figures (the bearded man
walking to the right of the gateway and the
man with the crown over his hat beside
the women on the right) wear garments
that are meant to suggest the draped
clothing of the ancient world (as opposed
to the tailored clothing of the fifteenth
century). The man with the crown over his
hat is Alexander, dressed in cloth of gold.
He stands with a group of women whose
clothing mixes that of the Burgundian
court with the exotic. The women are led
by Sisigambis, the Persian queen mother,
whom Alexander revered. But he had
inadvertently offended her by presenting
as a gift some clothes in the style of his
homeland, suggesting that, if she liked
them, her granddaughters could learn
how to make them, just as his own sisters
had. Here Alexander approaches her and
apologizes profusely, stating that he had
not realized that working with wool was,
for Persian women, the lowest occupa-
tion imaginable. According to the text, he
wears clothes his sisters had made, but in
reality it would have been just as unthink-
able for women of high rank around 1470
to make cloth of gold or clothes.

Within the illustration:

Cr commencr le ·vf· liure de quinte curse lequel contient en soy -
xxviii· Chapitree ,           Prologue du tranflateur ·ε·/

Ay empzunte
de Juftin et de
ozofe la fin du
quart liure
depuis le lieu
ou il dift aify
Ze toy daire en vne charette
perdue de plufieure plaies—

Jufquee a la fin dicellui liure
Pareillement Je prenetz defoie
acteure le commencement du
Chinquiefme liure enfieuant.
Jufquee la ou il dift · Au my
deftroit de la bataille Allec -
mift en pieces zc̄· Si ne lai
pae feulement tranflate axne

**87**

**Alexander Releases the Niece of Artaxerxes III, fol. 123**

Once again, many of the features of the courtiers' dress are contemporary, such as the gown sleeves that are slashed and even wound around an arm. Artaxerxes' niece was one of a number of Persian captives brought out to entertain guests at the lengthy, Persian-style banquets that had become, in the eyes of his fellow Greeks, a distressingly regular feature of Alexander's life, along with his adoption of opulent Persian dress. The girl should be at least partially veiled and casting her eyes downward to demonstrate the modesty that caused Alexander to suspect she was rather too well-born to be employed as an entertainer.

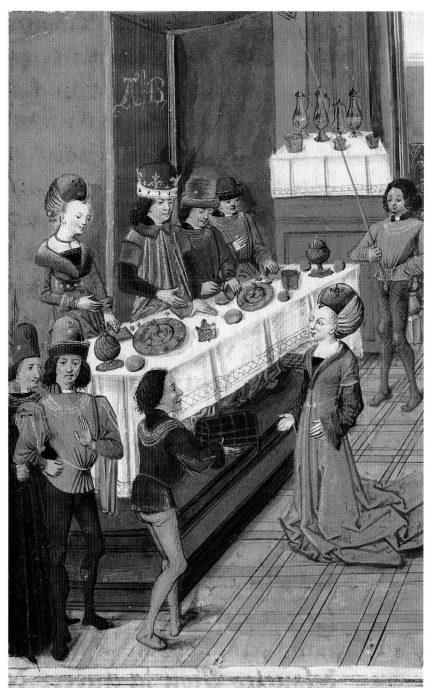

Ex commence le .vẹ̃ luure de quinte

Jour retourna a sa residence
puis renvoia Arthabaze a sa
maison Et luy donnant

double honneur et preemi
nence quil nauoit onques
eue devers Daire

Comment Narbazanes le traditre
zomes vindrent devers Alexandre

Et Thalestris royne des Ama
Chapitre · xiij.e

Tia estoient
venuz a la cite
de hyrcame ou
estoit le royal
pallaix du roy
Daire quant vint audevant
dalexandre Narbazanes par

saulfconduit luy apportant tres
grans dons entre lesquelz estoit
bagoe femme de singuliere
beaulte et en la fleur de sa
jeunesse Auec laquele avoit
jadis vse le roy Daire · Et peu
apres Alexandre en vsa aussi

**88**

**Bagoas Pleads on Behalf of Nabarzanes and the Amazons Visit Alexander, fol. 133v**

Bagoas, according to Quintus Curtius, was a young eunuch of remarkable beauty, who was a gift to Alexander from Nabarzanes. Disapproving of Alexander's feelings for Bagoas, Lucena altered the text to make him a woman. The illuminator has accordingly dressed him/her in an exoticized version of contemporary female dress. The trailing gauze sleeves may be a reference to the long slit oversleeves sometimes seen in Middle Eastern dress. The Amazons also wear versions of contemporary women's dress, although propriety may yet again have affected the image: some of the Amazons do expose their legs, as Quintus Curtius said they did, but none of them do what he also says they did—bare the left half of their chests. Alexander's courtiers have become more exotic looking, with a couple of them wearing short garments over long gowns: this must be an attempt to depict the effect of Alexander compelling his friends and his chief military men to join him in donning Persian dress.

**89**

**The Founding of Alexandria-in-Caucaso, fol. 156v**

Masons with improbable gold decoration on their clothes work on one of the many cities both founded by Alexander and bearing his name. The king himself is shown in black gilded armor under the now-usual short-sleeved outer garment, but he has also reverted to an earlier article of clothing, a piece of drapery, here rendered in an incoherent combination of green and blue. Hats with pointed fronts were often regarded as Greek (see fig. 73).

# Glossary of Dress and Fabric Terms

**almuce**  long, hoodlike garment made of fur, worn by canons (members of the clergy)

**brocade**  fabric in which contrasting colors are woven into specific areas to make patterns

*brunette*  black woolen cloth

**cendal**  lightweight silk, often used as lining

**chasuble**  fairly narrow vestment worn during Mass; joined only at the shoulders and open down the sides

**cloth of gold**  general term for fabric involving a lot of gold thread

**cope**  a cape-like vestment worn during Mass (instead of the chasuble) and in processions

*cote*  under-dress

*cote hardie*  sleeved garment that clung tightly around the upper body and revealed a great deal of the shoulders

**dagging**  slashed edges

**dalmatic**  short-sleeved vestment with vertical slits at the sides used during Mass

**doublet**  under-jacket

**dyaspin/diasper**  white-on-white patterned silk

**ermine**  white winter fur of a type of weasel, also utilizing the black-tipped tail

*giornea*  sleeveless overgarment joined only at the shoulders, rather like a poncho; short for men, long for women

*haincelin*  probably a short outer garment, fitting tightly at the hips

*houce*  long overgarment with elbow-length cape sleeves and white tabs on the chest

*houppelande*  high-collared and wide-sleeved gown, sometimes with slashed edges (dagging) on sleeves and, when worn by men, at hem

| | |
|---|---|
| **kermes** | the most expensive dye, made from crushed insects that lived on oak trees; produced the color crimson |
| *loros* | long, narrow gilded leather strip studded with jewels, part of the regalia of the Byzantine emperor |
| *mi parti* | clothing split vertically into halves of two different colors |
| **miniver** | gray and white fur of squirrel in winter |
| **miter** | cap with pointed front and back sections, worn by bishops, archbishops, and some abbots |
| **orphrey** | embroidered panel added to vestments |
| *pellote* | sleeveless, open-sided overgarment worn in Spain |
| **purple** | silk fabric, not necessarily in the color purple |
| **samite** | slightly shiny silk fabric with a diagonal rib in its structure |
| **scapular** | narrow, poncho-like garment |
| **scarlet** | the most expensive woolen material, often dyed with kermes, the most expensive dye |
| **strandling** | rusty red fur of squirrel in autumn |
| *surcote ouverte* | sleeveless, open-sided overgarment |
| **surplice** | linen over-tunic of clergy |
| **taffeta** | silk fabric of plain weave |
| *tiretaine* | fine woolen cloth |
| **tunic** | basic T-shaped garment of ancient Rome; term often used in Middle Ages for garment worn between shirt and overgarment |
| **velvet** | silk fabric with pile surface |
| **velvet cloth of gold** | velvet patterns against a background of gold threads, sometimes with loops of gold thread worked into areas of the velvet |
| **vermilion scarlet** | scarlet fabric dyed red with kermes |

# Suggestions for Further Reading

HERALD, JACQUELINE. *Renaissance Dress in Italy, 1400–1500*
(London: Bell & Hyman; Atlantic Highlands, N.J.: Humanities
Press, 1981).

MCKENDRICK, SCOT. *The History of Alexander the Great. An
Illuminated Manuscript of Vasco da Lucena's French Translation
of the Ancient Text by Quintus Curtius Rufus* (Los Angeles:
J. Paul Getty Museum, 1996).

MONNAS, LISA. *Merchants, Princes and Painters: Silk Fabrics in
Italian and Northern Paintings 1300–1550* (New Haven and
London: Yale University Press, 2009).

NEWTON, STELLA MARY. *Renaissance Theatre Costume and
the Sense of the Historic Past* (London: Rapp and Whiting,
André Deutsch, 1975).

SCOTT, MARGARET. *Medieval Dress and Fashion* (London:
British Library, 2007).

SCOTT, MARGARET. "The Role of Dress in the Image of Charles
the Bold, Duke of Burgundy," in *Flemish Manuscript Painting
in Context. Recent Research*, Elizabeth Morrison and Thomas
Kren, eds. (Los Angeles: J. Paul Getty Museum, 2007), 43–53.

VEALE, ELSPETH. *The English Fur Trade in the Middle Ages*
(Oxford: Oxford University Press, 1966).

## Online Resources

http://rose.mse.jhu.edu
Web site with illuminations of various manuscripts of the
*Roman de la Rose*

http://www.medats.org.uk
Web site of the Medieval Dress and Textiles Society

http://www.khm.at/en/treasury
Web site of the Treasury held at the Schatzkammer,
Kunsthistorisches Museum, Vienna

http://www.musee-des-tissus.com
Web site of the Musées des Tissus et des Arts décoratifs, a
textile museum in Lyon with examples of medieval fabrics and
clothing